INTERNATIONAL ENCYCLOPEDIA OF ART

Art of the Ancient Mediterranean World

first edition

Bernice Wilson

Facts On File, Inc.

INTERNATIONAL ENCYCLOPEDIA OF ART
ART OF THE ANCIENT MEDITERRANEAN WORLD

Text copyright © 1996 Bernice Wilson
Copyright © 1996 Cynthia Parzych Publishing, Inc.
Design, maps, timeline design copyright © 1996 Cynthia Parzych Publishing, Inc.

Facts on File, Inc.
11 Penn Plaza
New York NY 10001-2006

*Cataloging-in-Publication Data available on request from
Facts On File, Inc.*

Facts on File books are available at special discounts when purchased in bulk quantities
for businesses, associations, institutions or sales promotions. Please call our
Special Sales Department in New York at 212/967-8800 or 800/322-8755.

This is a Mirabel Book produced by:
Cynthia Parzych Publishing, Inc.
648 Broadway
New York, NY 10012

**To the memory of my Mother, Rachel (Ronnie) Cookson,
without whose guiding light this book would be unwritten.**

Edited by: Frances Helby
Designed by: Dorchester Typesetting Group Ltd.
Printed and bound in Spain by: International Graphic Service

Front cover: Marble bust of a Roman woman thought to be
Vibia Matidia, niece of Trajan, about 90–100 A.D.

10 9 8 7 6 5 4 3 2 1

Contents

Introduction ...5

1 Mesopotamian Art: The First Cities, 3500–2300 B.C.8
2 Mesopotamian Art: Power of the Gods, 3500–2300 B.C.10
3 Mesopotamian Art: Image of the King, 2350–1750 B.C.12
4 Egyptian Art: Art of the Old Kingdom, 3000–2200 B.C.14
5 Egyptian Art: Art of the Middle Kingdom, 2200–1650 B.C.16
6 Egyptian Art: Art of the New Kingdom, 1550–1360 B.C.18
7 Egyptian Art: Art of the New Kingdom, 1360–1070 B.C.20
8 Art of Ancient Crete: Minoan Palaces, 2000–1400 B.C.22
9 The Art of Mycenean Greece: Aegean Warriors, 1600–1200 B.C. ..24
10 Assyrian Art: The Palace of the King, 900–600 B.C.26
11 Assyrian Art: Images of Domination, 900–600 B.C.28
12 Babylonian Art: The City of Nebuchadnezzar, 600–500 B.C.30
13 The Art of Achaemenid Persia: A Cosmopolitan Empire,
 600–300 B.C. ...32
14 Greek Sculpture: The Quest for Reality, 700–450 B.C.34
15 Greek Art: Unity and Rivalry in Art, 700–450 B.C.36
16 Greek Art: Vases, Familiar Images, 700–450 B.C.38
17 Greek Art: Athens Supreme, The Parthenon, 450–430 B.C.40
18 Greek Art: Art and Death, 450–390 B.C.42
19 The Art of Hellenistic Greece: The Greek World Expands,
 323–30 B.C. ..44
20 The Art of Phoenicia and Carthage: Maritime Empire,
 900–150 B.C. ..46
21 The Etruscans: Italian Art Before the Romans, 800–300 B.C.48
22 Roman Art: The Presence of Imperial Rome, 500 B.C.–300 A.D.50
23 Roman Art: Roman Splendor, 500 B.C.–300 A.D.52
24 Roman Art: Roman Faces, 500 B.C.–300 A.D.54
25 Early Islamic Art: Art and Faith, 600 B.C.–1000 A.D.56
26 Early Islamic Art: Caliphs and Merchants, the Secular Art of
 Islam, 600 B.C.–1000 A.D. ..58

Bibliography and Acknowledgements ...60
Glossary ..61
Photo Credits ...62
Index ..63

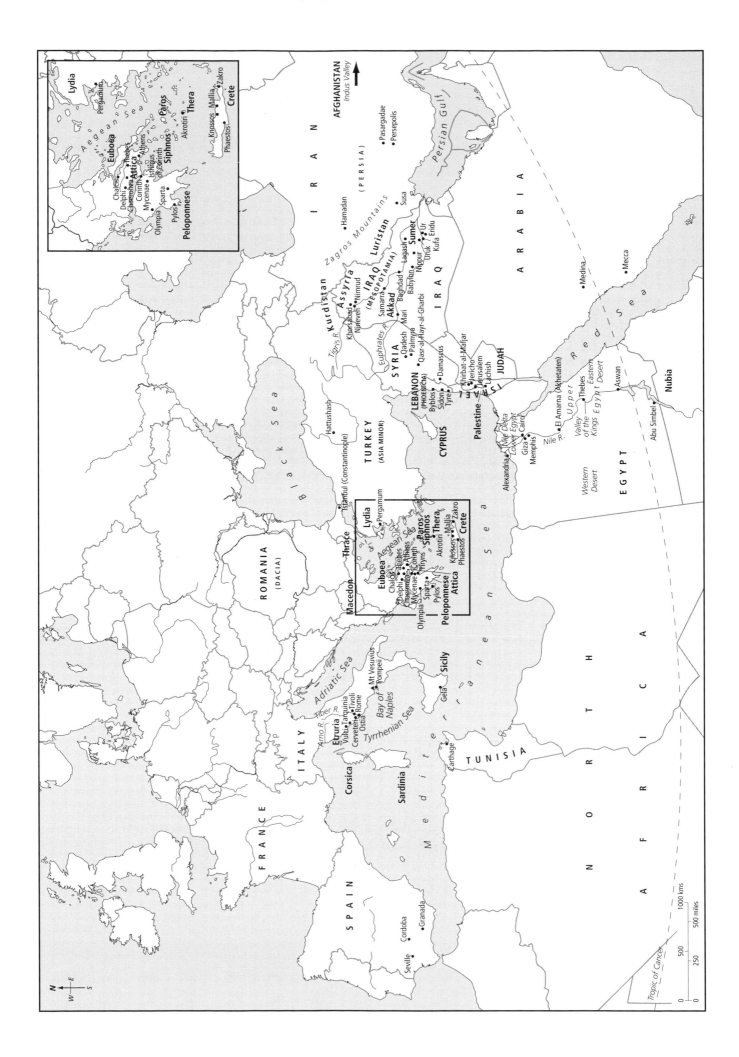

Introduction

This book covers more than four thousand years of history. It begins in approximately 3500 B.C. as the cities of the Sumerians emerged in southern Mesopotamia and ends about 1000 A.D in the lands of the Islamic empire. Between these dates, the ancient states and great empires of the Mediterranean and the Middle East rose and fell. This book aims to provide an introduction to the art of these civilizations and to explain the part art played in the history of all the ancient peoples of this area.

In the ancient world, the main patrons of art were usually the rulers of states. They determined the nature of the work artists were required to do. One of the most important functions of art was to produce images of the rulers. These images varied according to the rulers' positions in their particular societies. Sculptors and painters were often called upon to adorn great cities. The Babylon of Nebuchadnezzar, who reigned from 625 to 605 B.C., and the Athens of Pericles, who lived from about 490 to 429 B.C., were filled with the work of artists commissioned by the state. What remains today furnishes dazzling evidence of their skills.

A nation's wealth was created in part in the workshops of its craftsmen. Both Minoan Crete and the Phoenician city-states had many highly skilled craftsmen making good-quality products for the profitable export trade. This trade was the

Timeline

This timeline lists some of the important events, both historical (listed above the time bar) and art historical (below) that have been mentioned in this book. While every event cannot be mentioned it is hoped that this diagram will help the reader to understand at a glance how these events relate in time.

about 3500: The first cities are built in Mesopotamia (modern-day Iraq). The Sumerians develop a written language.

3100: Upper and Lower Egypt are united under the rule of a pharoah.

2700: Old Kingdom Egyptian civilization flourishes until 2000 B.C.

3500–2500 B.C.

about 2700: Egyptian art and architecture are made in the Old Kingdom style until about 2000 B.C.

2580–2500 B.C.: The sphinx and three great pyramids are built at Giza.

2340: Akkad conquers all of Mesopotamia.

2060–1650 B.C.: Egypt enjoys renewed power and prosperity during the Middle Kingdom period.

about 2040: The princes of Thebes unite Egypt.

about 2000–1450 B.C.: Minoan civilization on Crete is at its height.

2400–2000 B.C.

2400: The ziggurat of Nippur is built.

about 2340: A new form of secular art develops in Mesopotamia as the Akkadians erect *stelae* to celebrate their victories.

about 2000: A revival in the arts begins in Egypt and a style used throughout the country is developed.

about 2000–1450 B.C.: The Minoans build great palaces on Crete that are great artistic and craft centers.

about 1800: Babylon emerges as the leading power in Mesopotamia under King Hammurabi. All of Mesopotamia comes under Babylonian rule.

about 1600: The Minoans develop Linear A script.

1600–1200 B.C.: Mycenean Greek civilization dominates the Aegean.

Between 1550 and 1070 B.C.: Egypt reaches the height of power and prosperity.

1800–1550 B.C.

1792–1750 B.C.: Babylonian culture flourishes.

1600–1200 B.C.: Mycenean craftspeople produce objects for export such as pottery, jewelry and frescoes influenced by Cretan art.

1500–1070 B.C.: The arts in Egypt flourish. New temples are built while others are restored or extended. Luxury objects and paintings are in great demand.

foundation of the wealth of those states.

It was often through art that religious faith was expressed and communicated, from the statues of supplicants in the temples of Mesopotamia to the pages of the Koran in which the writing itself was the art. It was artists who brought reassurance in the face of death, by providing for what were believed to be the needs of the deceased in the next world. The funerary art of the Etruscans and the Egyptians provide the most vivid examples.

Art is generally built upon the experience of past generations and it forms the basis for the art of future generations. The art of Greece, which exerted so powerful an influence on Roman art, and in turn influences European and American art to this day, has its roots in Mesopotamia and Egypt.

The Mediterranean has been called the "cradle of civilization". Before the Mediterranean achieved this status, the focus of world history was immediately to the east in an area sometimes called "the Fertile Crescent." The mountain slopes on the northern edge of this area, in modern Turkey, Iraq and Iran, where there is considerable rain, was where humans first learned to domesticate and cultivate wheat and barley; they no longer had to depend solely on hunting and gathering for food. Now food could be grown in abundance, and any surplus could be exchanged for goods made by others. People began to specialize in particular kinds of work and settled communities developed into cities. Thus civilization began.

To the south of the mountains is a dry area through which two of the world's major rivers, the Tigris and the Euphrates flow. These rivers were unpredictable. In some years there were catastrophic floods and, in others, equally catastrophic droughts.

between 1400 and 650 B.C.: The kingdom of Assyria expands into a great power.

1390–1354 B.C.: The Hittites reach the height of their power.

1223: After the death of Ramesses II, Egypt is weakened by famine, disorder and invasion.

about 1200: The Hittite empire collapses. Mycenean civilization ends. Greece falls into a period of poverty and isolation for 300 years.

about 1000: Ancient Rome begins as a group of farming villages.

about 1000 to 70 B.C.: Phoenician civilization is in its golden age.

1400–1000 B.C. ➤

about 1000 to 700 B.C.: Phoenician craftspeople specialize in producing small luxury items.

Between 1400 and 650 B.C.: The Assyrian kings build palaces decorated with sculptures, painted low relief wall panels and paintings.

about 1390–1200 B.C.: The Hittite capital of Hattushash is surrounded by huge stone walls and gates. A huge open-air sanctuary exists. Cliffs above are carved with Hittite gods.

About 1356: Pharoah Akhenaten institutes great changes n Egyptian art. The human form is depicted as distored and the old ways of making religious art are rejected.

about 800–300 B.C.: Etruscan cizilization flourishes in central Italy.

776: The first athletic games are held at Olympia.

about 660: Egypt is conquered by Assyria.

by about 650: Greece becomes one of the great civilizations of the ancient world.

by 625: Rome grows into a small city ruled by Etruscan kings.

between 625 and 612 B.C.: The cities of Assyria are destroyed. Assyrian civilization dies away.

by 600: Carthage becomes the leading power in the Phoenician world.

800–600 B.C. ➤

700–600 B.C.: Etruscan art is influenced by the western Mediterranean and an orientalizing style develops.

about 600: Greek styles influence Etruscan art.

between about 650–450 B.C.: Greek sculptors master the portrayal of the human form in stone and bronze.

625–562 B.C.: The Caldean king Nabopolassar and his son launch a campaign to restore Babylon to its former glory.

600–300 B.C.: The people conquered by the Achaemenid kings build palaces and other buildings and decorate the buildings with low-relief sculpture.

about 525: Egypt is conquered by Persia. Persia becomes a powerful empire.

about 500: Etruscan power begins to decline.

510: The Romans establish a republican system of government.

480: The Persians bring terrible destruction to Athens.

479: The Persians are defeated by the Athenians and Spartans.

431–404 B.C.: Athens is defeated in the Peloponnesian War. Sparta becomes powerful.

550–400 B.C. ➤

by about 550: Athens becomes the most important center of pottery production in the Mediterranean.

500 B.C.–300 A.D.: Roman imperial art dominates the Roman world. Rome is beautified. Homes of the wealthy in the Roman empire are decorated with marble, frescoes, mosaics and sculptures, often inspired by Greek art and by Greek craftsmen.

about 470–460 B.C.: A new temple to honor Zeus is built at Olympia.

449: Athenians begin reconstruction of their war-damaged city led by Pericles.

between 447 and 432 B.C.: The Parthenon is built.

We call the land between these rivers Mesopotamia; today it is part of Iraq. People in Mesopotamia learned to tame the rivers with irrigation systems that carried water over great distances of this dry area to make it fertile. The irrigation of Mesopotamia was one of the world's greatest achievements. The system lasted for thousands of years.

Far to the south the great Nile River flows north from deep in Africa to the Mediterranean Sea. Along its length, people could farm and here, too, cities began to develop.

With specialization and cities came trade. With large-scale systems of irrigation and trade to administer, the need for record-keeping arose. People first began to make written records in Mesopotamia.

Gradually the written word, art and civilization spread around the shores of the Mediterranean Sea. In time the societies that flourished there declined, and in some cases disappeared, leaving only archeological evidence in the form of everyday objects, fragments of architecture and works of art. Using this evidence, archeologists and historians attempt to interpret how these ancient peoples lived and what they thought. In all of the societies covered in this book there was a written language of which many examples remain in the form of clay tablets and stone carvings. Even some manuscripts have been found. When historians have learned to read these, they have learned much about early civilization.

In this early period, the birth and death dates of major historical figures are often difficult to establish. In this book the dates when major figures ruled are included in most cases because the evidence for them is more reiable.

by 350: Sparta is in decline and other Greek states become weak and divided.

336: Alexander the Great becomes king.

332: Egypt becomes part of the Greek empire.

by 330: Alexander the Great destroys the Persian empire.

323: Alexander the Great dies. Babylon falls to ruin.

264: The first of three Punic Wars breaks out between Rome and Carthage.

218: Carthaginian forces led by Hannibal march from Spain through France, over the Alps, to Italy accompanied by 37 war elephants.

350–200 B.C.

336–323 B.C.: An idealized royal portrait syle is invented for Alexander the Great.

323–30 B.C.: Artists from the Hellenistic world are in demand to create portraits, public sculpture, luxury goods and other works.

146: The Punic Wars end. Carthage and its power are destroyed. Rome becomes powerful.

by 100: The Estruscans become part of the Roman world.

by 50: Rome controls the whole Mediterranean. The republican government collapses and civil war breaks out.

48: Julius Caesar assumes total power of Rome.

27: Augustus becomes emperor of the Roman world.

146–27 B.C.

between 180 and 150 B.C.: The Great Altar is built at Pergamum and dedicated to Zeus.

by 100: Roman artists develop a distinctive style of portrait sculpture.

79: Mount Vesuvius erupts destroying the city of Pompeii and many other Roman settlements around the Bay of Naples.

330: Constantinople replaces Rome as the capital of the Roman empire.

570: The Prophet Muhammed is born in the city of Mecca.

622: An Islamic state is established at Medina.

750: Spain, North Africa, Mesopotamia, Persia and Afghanistan are all under Islamic rule.

by 800s: The Abbasid empire begins to disintegrate.

50–1000 A.D.

about 50: It becomes fashionable in the Roman world to decorate walls with painted panels.

between 72 and 80 A.D.: The Colosseum is built in Rome.

113: Trajan's Column is built in Rome to commemorate the Dacia campaign of emperor Trajan.

about 135: Hadrian's Villa is built at Tivoli, near Rome.

312: The Arch of Constantine, the last of the great triumphal arches of Rome, is erected.

600–1000 A.D.: The Islamic arts flourish in the Muslim world.

1 Mesopotamian Art: The First Cities, 3500–2300 B.C.

The ziggurat of Nippur dates from about ▶ *2400 B.C. and was dedicated to Enlil, the Sumerian god of the wind. It was known as the House of the Mountain, Mountain of the Storm, Bond between Heaven and Earth. Its remains still loom over the ruins of the ancient city.*

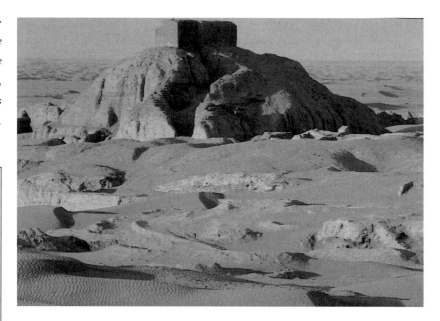

Mountain of the God

The skyline of every Mesopotamian city was dominated by the ziggurat, a huge, artificial mountain dedicated to the city's patron god. The temple of the god stood at the summit. Since there is no stone in Mesopotamia, ziggurats were, like all other buildings, constructed out of bricks made from river clay dried in the sun. To the Sumerians, the colossal form of the ziggurat, soaring to the sky, represented a link between man and the gods. ■

This Sumerian cuneiform tablet dates from about 2900 B.C. It records information about fields and crops. ▼

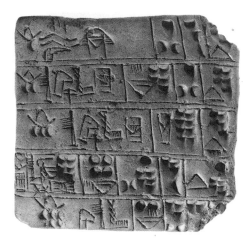

Just over five thousand years ago, one of the most important stages in human history began, the development of the earliest cities. This point marks the beginnings of civilization, a word which comes from the Latin word for city. Civilization became possible once farming replaced hunting as a way of life, and there was a tremendous increase in food production. Cities began to emerge in river valleys because the land there was fertile and could support large populations.

The very first cities grew up in Mesopotamia, which is now Iraq, a fertile land between the great Tigris and Euphrates Rivers. They were built in Sumer, in the south of Mesopotamia. These Sumerian cities,

Documents of Clay _____

The Sumerians developed a form of writing known as cuneiform. It was made up of wedge-shaped signs (the word "cuneiform" comes from the Latin word for wedge) inscribed on slabs, or tablets, of wet clay with the pointed end of a reed. Once dry, these tablets became very hard. Many thousands of Mesopotamian documents in the form of cuneiform tablets have survived. They cover a wide variety of subjects including business transactions, works of literature and historical records. ■

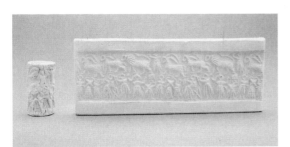

▲ *The stone cylinder seal on the left of the picture dates from about 2500 B.C. The impression it produces is on the right.*

Art in Miniature

Cylinder seals were made of limestone or colored stones such as lapis lazuli, carnelian or agate. Sumerian seals were carved with agricultural scenes, geometric patterns or royal banquets. When rolled over wet clay, they produced patterns that could be repeated and used as a signature. A merchant's seal, for example, would have an individual design used to identify goods he owned. ■

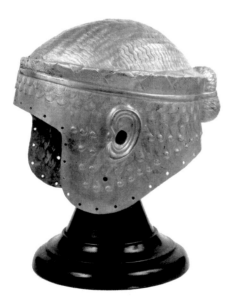

▲ *This helmet, made of beaten gold, dates from about 2500 B.C. and was buried in the tomb of one of the kings of Ur. It was made in the form of a wig with the hair arranged in waves and curls, a plaited chignon at the back.*

such as Ur, Nippur, Uruk, Lagash and Eridu, had populations of a size never before seen, sometimes tens of thousands. Their emergence led to entirely new opportunities for human progress and achievement.

The people of the new cities were governed by a rich and powerful ruling class of priests and kings who owned most of the land and cattle. Enormous workforces enabled the rulers to erect temples and palaces on a scale never possible before. The most spectacular type of building in the new cities was the ziggurat, or temple-tower.

The Sumerians were responsible for one of the greatest of human achievements, the invention of writing. Writing was originally used by the city administration to keep their accounts. Within a short time, people were making written records of many aspects of human life. Through the written word, civilizations have been able to preserve their beliefs, their history and their literature for succeeding generations.

The new cities provided many more opportunities for artists and craftsmen. Their vast populations required pottery in enormous quantities to use for storage, eating, drinking and cooking. The Sumerians developed a particular type of seal, a small cylinder made of stone with a design carved on the surface. They used them to establish ownership of their goods. Many thousands of these cylinder seals were produced in Mesopotamia. The presence of a wealthy section of society created a demand for luxury goods. Jewelry, furniture and ornamental objects were made in wood, gold, silver and precious stones. Very high standards of workmanship were achieved in all these fields.

Luxury items the Sumerian craftsmen made were in demand over a wide area. They were exported to Syria, Persia and Asia Minor, which is now Turkey, and as far afield as Afghanistan and the Indus Valley in what is now Pakistan. The Sumerians imported the raw materials they lacked such as timber, gemstones and metals. They developed an efficient transport network of rivers, canals and ports to move their goods. By their contribution to this flourishing trade, Sumerian artists played a vital part in the growth and prosperity of the new cities.

The Royal Graves of Ur

The rulers of Ur in about 2500 B.C. were buried in underground tombs surrounded by objects of great magnificence, presumably so that they could continue to enjoy their privileged lifestyle in the next world. Jewelry, daggers, bowls and goblets fashioned of gold and silver were included in the graves. There were also chests, musical instruments, gaming boards and ritual objects. Many of the early rulers' attendants were killed or involved in a ritual of mass suicide, so they could be buried with their masters. ■

2 Mesopotamian Art: Power of the Gods, 3500–2300 B.C.

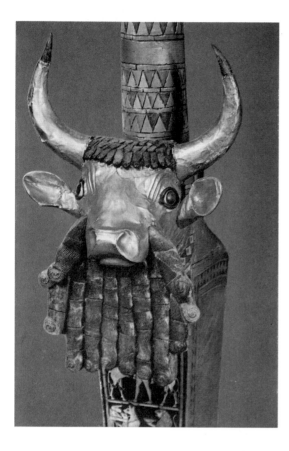

The Sumerians' religion lay at the root of their art. The spiritual beliefs of the Mesopotamians originated in the natural world they saw and experienced. The Sumerians worshipped aspects of nature in the form of numerous powerful deities who were thought to possess human form. The three supreme gods were An, god of the heavens; Enlil, the god of the wind; and Enki, who ruled over the fresh waters on earth. Beneath the supreme gods were Nanna, the moon god; Utu, the sun god; and Ishkur, god of storm, rain and weather. Other gods were connected with human and animal reproduction. One of the most important of these fertility deities was the goddess Inanna.

◄ *The moon god, Nanna, was the patron god of the city of Ur. Nanna was sometimes worshipped in the form of a mighty bull. A Sumerian prayer addresses him as "...Ferocious bull whose horn is thick... who is bearded in lapis..." This description exactly fits this bull's head from Ur which decorated a harp from a royal grave. It is dated about 2500 B.C. It is made of wood, overlaid with gold leaf, and lapis lazuli.*

The Resurrection of the God

The Sumerian god of crops and plants, Dumuzi, was often envisaged in the form of a wild goat. In a Sumerian hymn he is called "the leading goat of the land". Each year, when plant life perished in the terrible heat of summer, Dumuzi himself was believed to have died. In the New Year, when the spring rains came and life returned to the land, the god was supposed to have been restored to life. His return was celebrated with a great public festival. ■

This image of a ► wild goat peering through the branches of a plant dates from about 2500 B.C. It is one of the strange creatures found in the royal graves of Ur. The figure is made of wood and formed the base of a table where offerings to a god were placed. The head and legs are covered with gold leaf and the belly with silver leaf. The goat's horns, beard and mane are carved from lapis lazuli and his fleece from shell.

The Temple of the God

The building of a new temple was one of the most important duties of the ruler. Mesopotamian kings often commissioned pieces of sculpture to commemorate the event. In many of these sculptures, the king himself is shown as a builder's laborer in the service of the god. ■

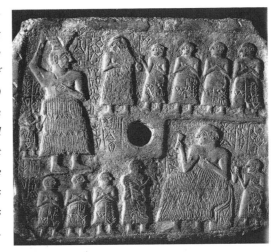

This stone plaque ▶ celebrates the building of a new temple by UrNanshe, ruler of Lagash, in about 2500 B.C. UrNanshe is shown carrying a basket of mud on his head and then at a feast celebrating the temple's completion. His larger size emphasizes his superiority.

The Sumerians believed that the fate of the human race lay entirely in the hands of the gods. They accepted that the gods frequently exercised their powers cruelly and unreasonably and that this often led to great human suffering. They believed that their best hope of a favorable destiny lay in trying to please the gods. This idea of service to the gods underlies Sumerian art.

The Sumerians erected many temples and shrines to the gods. Each Sumerian city placed itself under the protection of a particular deity who was believed to live within its walls. Uruk was dedicated to the worship of Inanna, who protected its people, while Enki was the chief god of the city of Eridu.

Each city erected a temple for its patron god to live in. The temple was staffed by a huge retinue of priests who ministered to the deity's needs as if he were a great lord. The god was served with splendid meals in fine vessels. He was supplied with rich robes and furnishings. Musicians provided him with entertainment. It was hoped that all this would persuade the god to continue to live with the community and look after its interests.

Every temple contained a richly decorated image of the god made from precious materials. Very few of these images have survived. Large numbers of smaller statues do, however, still exist. These represent individual worshippers in prayer and are moving symbols of the religious faith of the Sumerians.

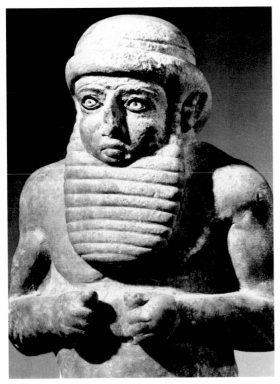

▲ This limestone statuette, of which only the top half survives, is from Uruk. It is dated about 3300 B.C. The man's distinctive cap shows that he is a prince. The statuette would probably have held a vessel for holding liquid offerings to the god. The Sumerian sculptor has portrayed an expression of wonder and entreaty on the face of the prince.

Stone Deputies

Sumerian statues were placed inside temples, standing before the sacred image of the god. The statue was thought to possess a life of its own. It was looked upon as a substitute for the person it represented. Its duty was to stand in constant prayer and adoration of the god in the hope of winning divine favor. ■

3 Mesopotamian Art: Image of the King, 2350–1750 B.C.

◄ *The strength and majesty of the Akkadian monarchy are illustrated in this bronze head of a king which dates from the Akkadian period (about 2340–2150 B.C.). It may represent Naramsin.*

The Sumerian cities were separate, independent powers. Although there were constant wars between them, no single city succeeded in dominating the others for any length of time. In about 2340 B.C., the situation changed. At that time Akkad, a region to the north of Sumer, became the leading power in Mesopotamia. Under a line of strong and ambitious kings, the Akkadians conquered the whole of Mesopotamia and their territory stretched from Persia, now part of Iran, to Syria.

The Akkadians were not of the same race as the Sumerians. Their language and traditions were different. Sumerian art had been fundamentally religious in purpose. Under the Akkadians, a new form of secular art developed. The aim of the art was to glorify the king and the military might of the Akkadian state.

The Akkadians used art as a form of propaganda to communicate the message

The Power of the King

The king held absolute power in the Akkadian state. The Akkadians imposed their rule on the cities of Mesopotamia by force. Any sign of rebellion was ruthlessly put down. Such was the power of the king that, to many of his people, he was the equal of the gods. The Akkadian king Naramsin (who ruled approx. 2291–2255 B.C.) was even declared to be a god. His title, King of the Four Quarters of the Earth, was later adopted by many Mesopotamian kings. Akkadian art reflects the supreme position of the king by showing him as a figure of immense power and dignity. ■

This sandstone stele dates ► *from the time of Naramsin and celebrates his victory against the Lullubi, a tribe on the Iranian border. The stele shows the Akkadian troops, with King Naramsin at their head. They triumphantly trample over their enemy. The king is depicted as larger than the other figures to indicate his supremacy, and his horned crown shows he is a god.*

A City Destroyed

The wealthy and influential city of Mari in northern Mesopotamia was conquered and destroyed by Hammurabi in about 1750 B.C. In the 1930s, over 17,500 cuneiform tablets from the royal archives were discovered. The tablets provided valuable information on Mesopotamian life between about 1800 B.C. and 1750 B.C. ■

that Akkadian power was invincible. Most surviving Akkadian sculpture is in the form of stone slabs or *stelae* (the singular form is *stele*). They were erected to celebrate the victories of the Akkadian armies. The enemy is always shown defeated and humiliated.

The Akkadian empire lasted until about 2150 B.C., when southern Mesopotamia was overrun by the Guti, a people from the Zagros mountains in modern Iran. The Guti remained in occupation for about sixty years until they were driven out by the Sumerians.

In about 2000 B.C., Mesopotamia was invaded by the Amorites from eastern Syria. The Amorites established kingdoms throughout Mesopotamia. In about 1800 B.C., one of these, Babylon, emerged as the leading power in Mesopotamia under its king, Hammurabi (who ruled 1792–1750 B.C.).

Hammurabi's military campaigns brought the whole of Mesopotamia under Babylonian rule. His conquests extended as far north as the important kingdom of Mari, in what is now Syria. Under Hammurabi's rule, Babylonian learning and culture flourished. Few sculptures have survived from this period. One of the most famous Mesopotamian works is the *stele*, inscribed with the code of laws drawn up during Hammurabi's reign. The image of the king on this *stele* is very different from the warlike figures of Akkadian art. Hammurabi is shown not as a mighty conqueror but as a pious and conscientious ruler.

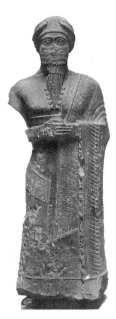

The kings of Mari reigned in great ▶ splendor. The royal palace contained over three hundred rooms and was magnificently decorated with wall paintings and sculptures. This stone statue represents Puzur-Ishtar who ruled during the period between about 2000 B.C. and 1800 B.C., although the exact dates of his reign are unknown. The king is shown richly arrayed in his royal attire. His beard is elaborately curled and braided. He is wrapped in a woolen shawl which is decorated with a deep fringe. The horns on the round cap indicate that he regarded himself as a god.

The Laws of Hammurabi

Hammurabi's code of laws covered every aspect of family and community life in ancient Babylon. The king stated that his intention was "to cause justice to prevail in the land, to destroy the wicked and the evil, that the strong might not oppress the weak." The code has survived inscribed on a *stele*, seven feet/more than two meters high. A sculpture at the top of the *stele* shows Hammurabi receiving his authority from the Babylonian sun god, Shamash, who was also the god of justice. The clear message of the *stele* is that the code of laws was given to the king by the gods. ■

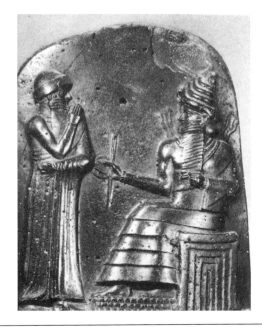

◀ *The law code of Hammurabi was inscribed during the latter years of his reign on this stele made of diorite, a hard, black stone. It shows Hammurabi standing before the sun god, Shamash. The king's right hand is raised in a gesture of respect. Rays of sunlight stream from the god's shoulders.*

4 Egyptian Art: Art of the Old Kingdom, 3000–2200 B.C.

Symbols of Power

The pyramids at Giza formed part of a vast complex including temples, the smaller pyramids of other members of the royal family, tombs of the nobles and the sphinx, the colossal rock statue of a recumbent lion with a king's head. Until about 1550 B.C., most of the kings of Egypt were buried in pyramids. The pharaoh had the right to call upon the peasants to work on huge building projects of this kind. Pyramids were generally built while the Nile was in flood, the hottest time of the year, when farming was at a standstill. These gigantic structures, towering over the landscape, were symbols of the power and wealth of the pharaohs. ■

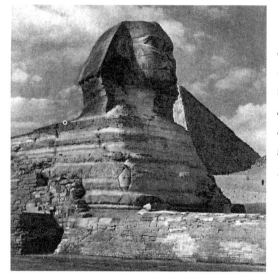

◀ The sphinx and the three great pyramids at Giza (only one can be seen here) that were constructed about 2580–2500 B.C., embody in stone the might of the Old Kingdom pharaohs.

The great civilization of ancient Egypt owed its existence to the Nile River. In a desert, where rain was almost nonexistent, the production of food depended completely upon the fertility which this great river brought to the land. It is no different today. Each year in Egypt the Nile, swollen by rain in the highlands of Ethiopia, rose and broke its banks, flooding the fields and leaving a fertile deposit of rich, black mud. This alone made it possible to cultivate the land. If the annual floods were not high enough, famine and starvation could result.

Until about 3100 B.C., Egypt consisted of two separate kingdoms: Upper Egypt in the south and Lower Egypt in the north. From then on, the two kingdoms were united under the rule of a supreme king, the pharaoh, with his capital at the city of Memphis.

The period of Egyptian history from about 2700 to 2200 B.C. is known as the Old Kingdom. During this time Egypt produced some of

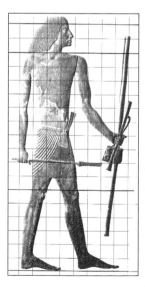

◀ This diagram shows how standing figures were divided into eighteen rows of squares in order to arrive at the correct proportion of each part to the rest. This figure is the scribe, Hesire, who was alive in about 2670 B.C. He is shown holding his writing materials and his rod, the symbol of his important office. Hesire's head, legs and feet appear as if seen from the side. His shoulders, chest and eye appear as if viewed from the front.

Rules of Art

Egyptian artists were governed by strict rules regulating the form in which their work was produced. Some of these rules controlled the proportions of the human body, the size of each part as compared with the rest. The artist had to show as much of the body as possible, since only the visible parts could survive after death. Some parts of the body are, therefore, depicted as if seen from the side and others as if viewed from the front. ■

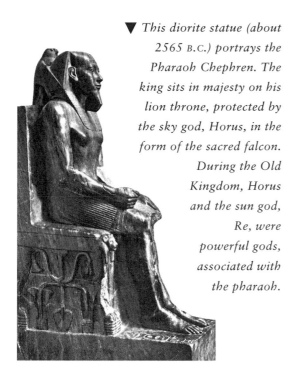

▼ This diorite statue (about 2565 B.C.) portrays the Pharaoh Chephren. The king sits in majesty on his lion throne, protected by the sky god, Horus, in the form of the sacred falcon. During the Old Kingdom, Horus and the sun god, Re, were powerful gods, associated with the pharaoh.

In this painted relief found in his tomb, the priest Ptahhotep, who was alive in about 2450 B.C., is shown sitting at a table. He is wearing a leopard skin as a sign of his priestly status. Food is piled before him to provide him with eternal nourishment. Egyptian priests made up a privileged group of the community. ▼

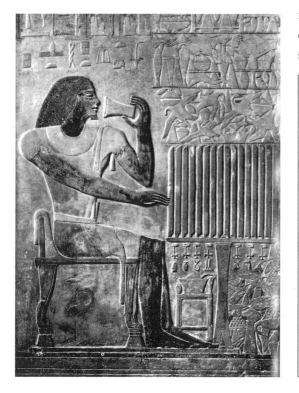

the most admired works of art and architecture ever created. The most spectacular monuments are the pyramids at Giza, containing the tombs of the Pharaohs Cheops (who ruled 2606–2583 B.C.), Chephren (who ruled 2575–2550 B.C.) and Mycerinus (who ruled 2548–2530 B.C.).

Ancient Egypt was ruled by a small, immensely rich and privileged section of the population. These people were the pharaoh, the nobility, the great officials of state and the priests. Most Egyptian artists worked for the royal court or the great temples. The art which they produced had to comply with strict rules and traditions.

One of the most important purposes of Egyptian art was to represent the pharaoh. Old Kingdom art reflected the exalted position of the pharaoh in Egyptian society. He was not shown realistically but in an idealized way. He was depicted as a calm and noble figure eternally young. He was often represented in company with the gods because he was believed to be their equal.

Custom required that all members of the royal family should also be portrayed as perpetually young. Other rules applied to those officials who were not of royal blood. They were depicted with the trappings of their position and status. They could, however, be shown in a more lifelike way than royalty could.

The importance the Egyptians attached to regulating art was connected with the role it played in religious life. They went to enormous lengths to try to achieve survival after death. They believed that the image of a person, in painting or sculpture, could be given immortality if the correct magical procedures were followed. It was necessary for the image to show every part of the person clearly. It was this concern that explains the particular way in which the human body was shown in Egyptian art.

Life After Death

The ancient Egyptians believed profoundly that, provided the right steps were taken, the dead could survive in another world. They thought it necessary to preserve the corpse from decay and to supply the deceased with all its needs in the next life. The body was preserved by a complicated process which involved removing the internal organs. It was dried out with chemicals, and the cavity packed with linen. The body was then wrapped with bandages. A corpse treated in this way is known as a mummy. The deceased was given a home, the tomb, and provided with food and drink, clothing, furniture, servants and enjoyable pastimes such as feasting and hunting, in the form of sculptures, paintings or models. The Egyptians believed that these could be magically endowed with everlasting life. ■

5 Egyptian Art: Art of the Middle Kingdom, 2200–1650 B.C.

The death of the Pharaoh Pepi II (who ruled 2278–2184 B.C.) brought the Old Kingdom to an end and Egypt passed into more than a century of crisis. Conflict broke out at court, the central government collapsed and the king's authority practically ceased to exist. Foreign nomads infiltrated the Nile delta. The Nile floods were low and

Turmoil in the Land

The calamities between the end of the Old Kingdom and the establishment of the Middle Kingdom (about 2180 to 2040 B.C.) are recalled in a text of the period: "... *the poor have taken possession of the property; he who formerly could not afford a pair of sandals is now the possessor of treasures; the wealthy lament while the poor rejoice. . . . Fire consumes the palace, the colonnades, and in the provinces buildings are destroyed. Gold, silver and precious stones now adorn the necks of slave girls, while noble ladies sigh, 'Ah, if only we had something to eat."* ■

This wooden model (approx. 2100 B.C.) of a troop of soldiers recalls the war and upheaval before the foundation of the Middle Kingdom. The dark-skinned warriors are from Nubia, to the south of Egypt. Small wooden figures were often placed in tombs for it was believed they would perform services for the tomb's owner in the afterlife. ▼

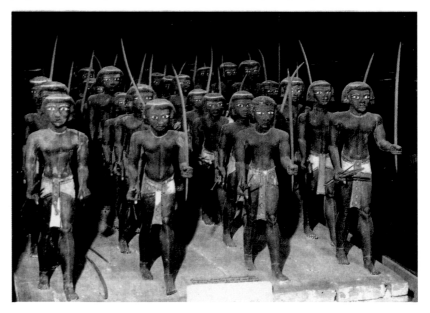

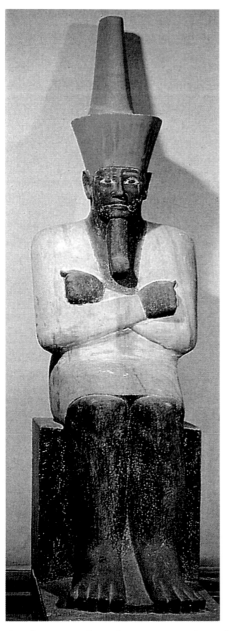

▲ *This painted sandstone statue, from the reign of Pharaoh Mentuhotep I (who ruled 2060–2010 B.C.), is typical of the early sculpture produced at Thebes. It shows the pharaoh in the guise of Osiris, the god of the dead. The statue is roughly made but gives an impression of tremendous power.*

The Art of Thebes

The Old Kingdom had left no works of art at the new capital of Thebes to serve as models for the new court artists. During the first years of the Middle Kingdom, a distinct style of sculpture was produced by artists at Thebes. Their work was coarsely executed but possessed a quality of brutal strength. ■

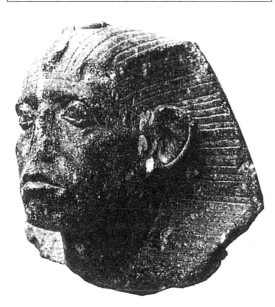

▲ *The weary face of Sesostris III is depicted in this granite head of about 1850 B.C.*

The Cares of Kingship

Many of the royal portraits produced during the Middle Kingdom seem to create an image of pessimism and disillusion. This is particularly so with Sesostris III (who ruled 1878–1842 B.C.), who is portrayed (above) as a middle-aged man exhausted by worry and responsibility. The artist does not shrink from showing the furrows on his face and the hollows under his eyes. This is quite different from the eternally youthful image of the Old Kingdom pharaoh. ■

famine and starvation followed. The desperate peasants rebelled. Tomb robbers ransacked the pyramids and desecrated the royal graves. Civil war erupted throughout the country. Eventually, in about 2040 B.C., the princes of the southern Egyptian city of Thebes united the country under their rule.

Pharaoh Mentuhotep I (who ruled 2060–2010 B.C.) was the first king of the new dynasty. The period from 2060 to about 1650 B.C. is known as the Middle Kingdom when Egypt enjoyed renewed power and prosperity. The country was fortified against foreign invasion. Irrigation and land reclamation projects were carried out to avoid further famine.

Civil war resulted in a decline in the arts in Egypt. During the reign of Mentuhotep I, the process of revival began. The Old Kingdom royal court and artistic center, located at Memphis in the north, was moved to Thebes under Mentuhotep. Initially, Theban sculpture was crude in comparison with the art produced in the north. By about 2000 B.C., Egyptian artists developed a style used throughout the country. High artistic levels were once more being achieved.

The focus of Middle Kingdom art was the king. More statues of the pharaoh were made than of private individuals. Royal sculpture reflected the majesty and power of the Theban kings. It also expressed a very different concept of kingship from that of the Old Kingdom.

Egyptians no longer saw their king in the same way. The pharaoh failed to save the country and his people dared to rise up against him. The art of the Old Kingdom showed the pharaoh as a god, ageless and remote. The art of the Middle Kingdom shows him as a human being with enormous responsibilites.

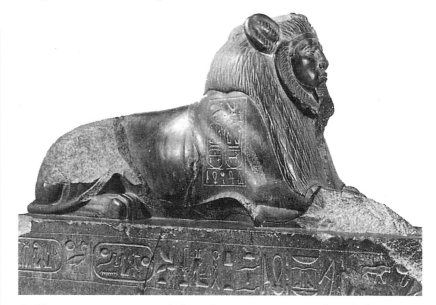

▲ *The grave countenance of Pharaoh Ammenemes III (who ruled 1842–1797 B.C.) is carved on this sphinx of black granite (about 1800 B.C.).*

6 Egyptian Art: Art of the New Kingdom, 1550–1360 B.C.

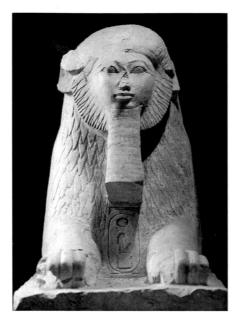

▲ *This limestone sphinx of about 1470 B.C. shows Queen Hatshepsut with the face of a young girl. Tradition made it necessary to give her a beard.*

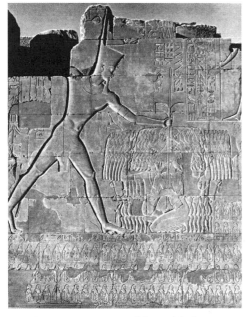

▲ *This limestone relief from Thebes (about 1460 B.C.) symbolized Egypt's humiliation of its enemies.*

In about 1650 B.C., large parts of Egypt came under the control of the Hyksos, an Asiatic people from Palestine. It is not clear whether the Hyksos achieved power by conquest or if they gradually filtered into the country. Egypt remained under foreign domination until about 1550 B.C., when the Hyksos were finally driven out by the princes of Thebes.

After the expulsion of the Hyksos, a new royal dynasty was established at Thebes and the Egyptians embarked on a policy of conquest to protect themselves against further foreign domination. Led by a series of great warrior kings, their armies swept north into Palestine and Syria, and south into Nubia, where they imposed Egyptian rule.

The period of Egyptian history from about 1550 to 1070 B.C. is known as the New Kingdom. During this time Egypt reached the height of her power and prosperity. Huge riches flooded into the country from the new empire. The royal family and the upper classes enjoyed a life of splendor and luxury. In this setting, the arts in Egypt flourished as never before.

The pharaohs of the New Kingdom instituted great building projects. Magnificent new temples were erected in the principal cities. Existing shrines were repaired or extended. Particular attention was lavished on the capital, Thebes, where Queen Hatshepsut (who ruled 1478–1457 B.C.) built a beautiful temple which rose in terraces from the foot of the cliff. The temple was made of gleaming white limestone and was lavishly decorated with sculptures glorifying the queen and her deeds. Following her death, Pharaoh Tuthmosis III (who ruled 1479–1425 B.C.) adorned the sacred precincts of the city with splendid new buildings and sculptures.

These grandiose schemes required huge manpower and enormous

The Image of Conquest

The military triumphs of the New Kingdom introduced a new view of the king into Egyptian art. The pharaoh was now depicted as a mighty warrior and the savior of his country. He was portrayed as a huge figure towering over the humiliated enemy. The pharaoh also personified the military might of Egypt itself. Images of this type were propaganda, designed to communicate the message that Egypt was invincible. ■

The Woman Pharaoh

Queen Hatshepsut was the only woman to rule Egypt for any length of time. The depiction of a woman as ruler was new to Egyptian art. Hatshepsut had herself portrayed in the historic guise of the pharaoh but, also, with feminine characteristics. Her stepson, Tuthmosis III, was kept out of power until her death. When he came to the throne many of the statues of her were destroyed. ■

quantities of building materials. During peacetime, the army was mobilized as a labor force. Prisoners of war were also pressed into service. New quarries were opened to ensure that plenty of stone was available. This concentration of resources made it possible to complete building work within a comparatively short period.

There was a great demand for luxury objects and paintings. Exquisitely decorated furniture, jewelry and ornaments were produced. Egyptian artists decorated the walls of tombs with elegant and graceful scenes of court life. The art of the New Kingdom vividly reflects the wealth and the pleasures enjoyed by the men and women of Egypt's privileged ruling class.

A Life of Ease

Wealthy Egyptians attached to the royal court were buried in tombs cut out of the rock in the cemetery at Thebes. These tombs were richly decorated with paintings showing aristocratic life in New Kingdom Egypt. Many of the paintings depicted splendidly attired men and women enjoying feasts and other entertainments. Some scenes portrayed Egyptians involved in outdoor amusements such as hunting and fishing. ■

▲ *On this tomb painting from Thebes of about 1360 B.C. wealthy Egyptians enjoy themselves at a banquet. They are served by slave girls, and dancers and musicians perform for them. The guests carry lotus flowers as a symbol of rebirth. They wear cones of scented wax which melt in the heat and fill the air with fragrance. Jars of wine are decorated with flowers and vine leaves.*

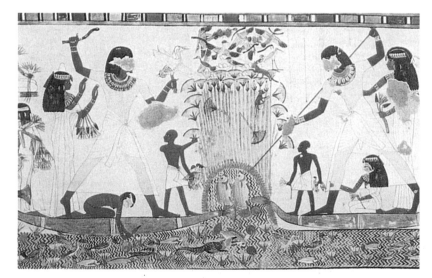

▲ *In this tomb painting from about 1380 B.C. Menna, the royal steward, is shown boating with his family in the marshlands of the Nile. Menna is depicted twice, hunting birds and spearing fish. His little daughter picks a water lily from the water. Menna's face was destroyed in ancient times by thieves who broke into the tomb to steal its contents.*

7 Egyptian Art: Art of the New Kingdom, 1360–1070 B.C.

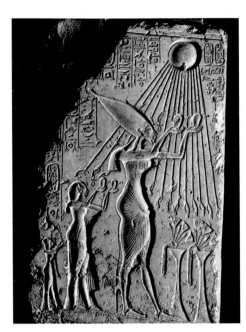

▲ *Akhenaten and his family pay tribute to Aten in this relief of about 1352 B.C.*

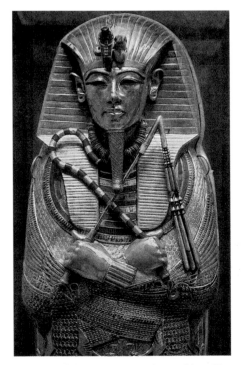

▲ *Tutankhamun lies on his gold coffin made in about 1330 B.C.*

By about 1400 B.C., Egyptian power was waning. Her territories in Palestine and Syria were difficult to control and subject to constant rebellions. From this time, Egyptian supremacy over the area was challenged by the Hittites, from Asia Minor, now Turkey.

Egypt's decline accelerated during the reign of Pharaoh Akhenaten (who ruled 1356–1339 B.C.), when the empire was neglected. Akhenaten tried to bring about huge changes in Egyptian religion. He decreed that the only god to be worshipped in Egypt was Aten, the disk of the sun. Akhenaten (whose name means "It pleases Aten") moved the capital from Thebes to a new city called Akhetaten (meaning "the Horizon of Aten"). The site of Akhenaten's city is now known as El-Amarna, so his rule is often referred to as the Amarna period.

As part of his religious revolution, Akhenaten instituted great changes in the art of Egypt. He discarded the old forms associated with the traditional gods. He introduced a new style of sculpture and painting, different from anything which had been seen previously. In the art of the Amarna period, the human figure was depicted in a strange, distorted manner. There are various possible explanations for this.

The religious reforms infuriated many Egyptians, particularly the powerful priesthood. Within a few years of Akhenaten's death in 1339 B.C., the court returned to Thebes and the old traditions were restored.

Akhenaten's successor, the young Tutankhamun (who ruled 1339–29 B.C.), reigned for only ten years. A chance of history has made him one of the most famous of the pharaohs. Alone of all the Egyptian kings' tombs, Tutankhamun's tomb was found almost intact

The Art of Akhenaten _____

The artists of the Amarna period broke with the traditions of the past. Egyptian art had previously glorified the king. Now, Akehanaten was portrayed in a most unflattering way, with an elongated jaw, a thin neck, limbs like matchsticks and a prominent belly. It is possible that Akhenaten ordered his artists to show him realistically and that he actually looked like this. An alternative explanation is that once the old rules had been rejected, artists went to the other extreme. They had been expected to idealize the pharaoh. They now did the opposite and emphasized his physical defects. ■

The Valley of the Kings

Until the New Kingdom, most of the Egyptian kings continued to be buried in pyramids. However, these massive structures called attention to the royal graves and put them at risk from thieves. In an effort to defeat the grave robbers, a new type of tomb was introduced for the pharaohs of the New Kingdom. Their graves were cut deeply into the rock in the lonely Valley of the Kings, outside Thebes, with no visible sign of their presence outside. However, in spite of these safeguards, it proved almost impossible to protect the royal tombs from looting, particularly between about 1200 and 1000 B.C., when the authority of the monarchy was declining. ■

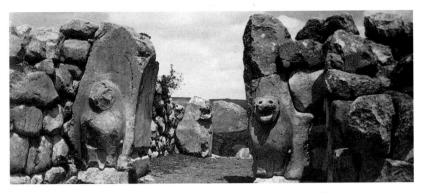

▲ One of the gateways into the city of Hattushash was flanked by sculptures of roaring lions about 1350 B.C.

in the royal cemetery near Thebes, the Valley of the Kings. The magnificent contents of the tomb show the wealth of New Kingdom Egypt and the skill of its craftsmen.

During Akhenaten's reign, most of Egypt's empire was lost. In about 1300 B.C., a new dynasty came to the throne and succeeded in regaining much of Syria and Palestine. The third king of this line, Ramesses II (who ruled 1290–1223 B.C.), was the most prolific builder in Egyptian history. Enormous projects were undertaken throughout the country. Many temples were decorated with colossal statues of the pharaoh, gigantic symbols of Egyptian royal power.

During the reign of Ramesses II, the struggle with the Hittites for control of Syria came to a head. Eventually, after the battle of Qadesh in 1286 B.C., the Egyptians were forced to acknowledge the Hittite territories in northern Syria. After the death of Ramesses II in about 1223 B.C., Egyptian power again declined. The country was weakened by famine, disorder and invasion. In about 1000 B.C., Egypt split again into separate northern and southern kingdoms. No longer an imperial power, Egypt was conquered by Assyria in about 660 B.C. and, in 525 B.C., by Persia. With the conquest by the Macedonian king, Alexander the Great (who ruled 336–323 B.C.) in 332 B.C., Egypt became part of the Greek world.

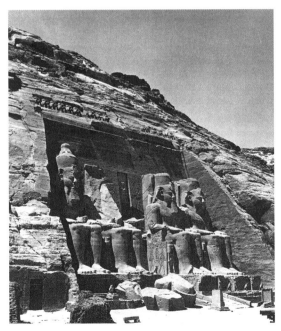

▲ A temple was carved out of the limestone cliff at Abu Simbel, in Nubia, to celebrate the thirtieth year of the reign of Ramesses II about 1260 B.C. In the 1960s it was moved to the top of the cliff and reconstructed so that temple would not be submerged by the waters of the new Aswan Dam.

The Hittites

The Hittites reached the height of their power under the rule of their great king, Suppiluliumas (who ruled 1390–1354 B.C.). The heavily fortified capital at Hattushash was surrounded by huge stone walls with gates flanked by watchtowers. Nearby was a vast open-air sanctuary where the cliffs were carved with processions of the Hittite gods. The Hittite empire collapsed in about 1200 B.C. as a result of internal unrest and foreign invasion. ■

8 Art of Ancient Crete: Minoan Palaces, 2000–1400 B.C.

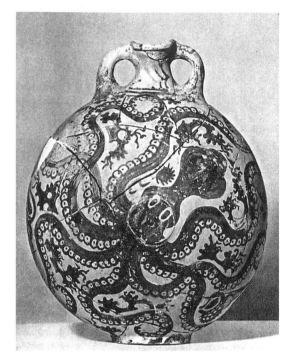

▲ *Ancient artists of Crete decorated their pottery with abstract designs or with natural forms such as plants or marine life. An octopus is depicted on this Minoan pottery flask dating from about 1500 B.C. Sea creatures must have been familiar to these island people.*

Legend of Minos

Greek legend tells of Minos, king of Crete, whose navy dominated the seas. Minos forced the people of Athens to send youths and maidens as a sacrifice to the Minotaur. The Minotaur was a monster—half man, half bull—who was kept in the winding maze of the Labyrinth. He was eventually killed by the hero, Theseus. The legend may recall the complicated layout of the palace at Knossos, the sea power of ancient Crete and religious rites in which bulls played a part. ■

The island of Crete, in the eastern Mediterranean, is only 170 miles/216 kilometers long and, in places just eight miles/thirteen kilometers wide. Yet here the first great European civilization developed. This civilization was at its height from about 2000 B.C. to 1450 B.C. Sir Arthur Evans (1851–1941), the English archeologist who worked on the island between about 1900 and 1932, called the ancient Cretan civilization "Minoan" after Minos who, legend tells us, was king of Crete. We do not know if Minos really existed.

Ancient Crete had many natural advantages. It was self-sufficient in food, the clay soil was ideal for making pottery and there was timber and stone on the island. There were many places around the coast where ships could safely anchor. The Minoans were a nation of seafarers and traders. They made full use of their environment to create a prosperous society in which artists and craftspeople performed an essential role.

At the heart of Minoan civilization lay the great Cretan palaces. The largest of these was discovered at Knossos. Others have been found at Phaestos, Mallia and Zakro. Minoan palaces fulfilled many functions and were built around a great central courtyard. The palace was the headquarters of government, the royal residence and a religious center. Local agriculture was managed and food supplies stored there. Writing was developed to help with the complex palace administration. The Minoans first used a type of hieroglyphics, or picture writing. After about 1600 B.C., they developed a script of straight or curved lines, known as Linear A. Neither of these systems has, as yet, been deciphered.

The palaces were also great artistic and craft centers, with workshops where many types of object were made to a very high standard. The Minoans made a huge variety of pottery including bowls, jars, incense burners and lamps. They carved graceful vases from beautiful, colored stone. Working in gold, silver and bronze, they turned out splendid vessels and jewelry. Officials in the palace organized the supply of raw materials to the workshops and the distribution of finished goods.

The products of the Minoan craftspeople formed the basis of a flourishing trading empire. Minoan ships exported them to the mainland and islands of Greece, to Asia Minor, now Turkey, Cyprus and Egypt. Crete imported raw materials such as ivory, lapis lazuli, silver and gold and other metals. This commerce was a vital factor in the island's prosperity.

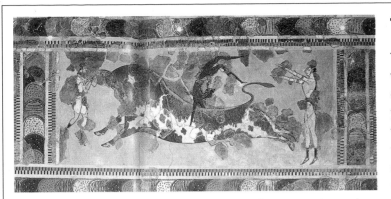

▲ *This fresco from the palace at Knossos (1500 B.C.) shows the popular entertainment of acrobats vaulting onto a bull's back.*

The Frescoes of Knossos

The most magnificent of the Minoan palaces was at Knossos. It contained majestic halls and corridors and a grand staircase linking the courtyard with upper and lower floors. The walls of the palace were decorated with richly colored frescoes. Many of these showed elegant ladies, graceful courtiers and the entertainments and rituals of palace life. Other frescoes showing animals and sea creatures illustrated the Minoan love of nature. ■

In about 1450 B.C., the palaces of Crete suffered fearful destruction by fire. There are some who argue that the cause of this catastrophe was the eruption of a volcano on the island of Thera, also known as Santorini. Others say that the palaces were destroyed by the Myceneans, warriors from mainland Greece. The golden age of Crete was at an end.

This gold signet ring from ancient Crete dates from about 1450 B.C. and is engraved with a religious scene. It shows priestesses dancing in honor of a goddess, a tiny figure flying down from the sky. Scenes of worship also appear on vases. The Minoans worshipped the forces of nature in the form of goddesses who ruled over their crops and herds. They held life and death in their hands. ▼

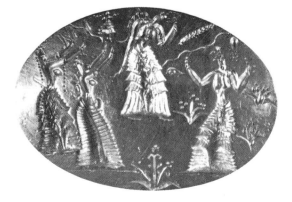

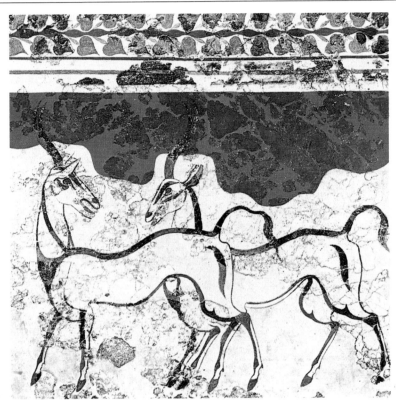

▲ *Graceful antelopes appear in a fresco from Thera dating from about 1550 B.C. Other frescoes found at Thera show its springtime landscape and the voyage of a fleet of ships.*

A Buried City

In about 1500 B.C., the volcano on the island of Thera exploded and buried its ancient towns under a thick layer of volcanic ash. In 1967, archeologists began to excavate the town of Akrotiri. They found well-preserved houses decorated with brilliantly colored frescoes which were strongly influenced by Minoan art. ■

9 The Art of Mycenean Greece: Aegean Warriors, 1600–1200 B.C.

The Lion Gate of Mycenae

The principal entrance to the citadel of Mycenae is known as the Lion Gate. The Lion Gate is decorated with an impressive relief sculpture portraying two lions. One lion stands on either side of a column. The heads of the lions are now missing. In common with other Mycenean cities, the walls of Mycenae were built from huge boulders cemented together with clay and small stones. The Greeks later called such structures Cyclopean because they were believed to have been the work of the Cyclopes, mythological giants with only one eye. ■

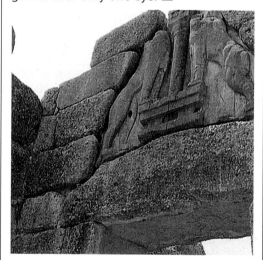

▲ *The magnificent stone lions above the main gate of Mycenae were erected in about 1250 B.C. The huge defensive walls of the city were built about 1400 B.C. and were extended over the next two hundred years. They are about fifteen feet/four and a half meters thick and were probably about fifty feet/fifteen meters high.*

After the fall of Minoan Crete in about 1450 B.C., the civilization of mainland Greece dominated the lands of the Aegean. This early Greek culture takes its name from its leading city, Mycenae. Other cities such as Tiryns, Pylos, Athens and Thebes (not the same as the Egyptian city of Thebes) were all part of the Mycenean world. Great warrior kings ruled from heavily defended citadels. Between about 1600 B.C. and 1500 B.C., the kings of Mycenae were buried in graves which contained huge quantities of treasure. The richness of these tombs shows their wealth and power.

The Myceneans inherited much of the civilization of Crete, including the palace system. They adapted the Minoan Linear A to their own Linear B script. Linear B has been deciphered, and it is an early form of Greek. The Myceneans took over the seafaring empire of the Minoans and extended their trade networks from Syria and Palestine in the east to Sicily and southern Italy in the west.

Like the Minoans, the Myceneans looked to their craftsmen to supply them with objects for export. Mycenean pottery, in particular, was of very high quality. It was much in demand in Greece and overseas in Italy, Asia Minor, now Turkey, Syria and Egypt.

Mycenean art was heavily influenced by Cretan art. The walls of Mycenean palaces were decorated with frescoes, a form of decoration borrowed from Crete. Mycenean potters developed the designs which the Minoans had taken from nature. Mycenean and Cretan jewelry were very like each other.

However, Mycenean society was fundamentally different from that of Crete. The Minoans had inhabited a peaceful world. The Myceneans lived in an age of constant warfare. Their cities were perpetually engaged in conflict or under threat of invasion. Most of the male population probably received military training and was called upon to fight in an emergency. The aggressiveness of Mycenean civilization is reflected in the work of its craftsmen and artists.

Mycenean metal workers produced superb armor and weapons for their soldiers. The frescoes in Mycenean palaces showed warfare and hunting as well as the processions which appeared in Minoan frescoes. Mycenean signet rings were engraved with battle and hunting scenes in addition to the religious subjects on Minoan rings. War chariots and foot soldiers were new subjects on painted pottery.

In about 1200 B.C., Mycenean civilization, like that of Crete, ended

The Graves of the Warriors

Between about 1600 and 1500 B.C., the kings of Mycenae were buried with their wives and companions in shaft graves, rectangular pits cut into the rock and lined at the foot with stone to form a burial chamber. The dead ruler would be placed, fully dressed and adorned with gold, on the floor of the tomb. A gold death mask was placed over his face. Treasures of gold, silver and bronze were put into the tomb. As befitted a great soldier in death, many of the treasures were weapons and other objects used in battle. ■

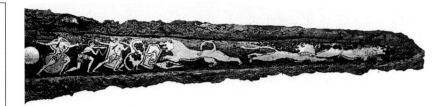

▲ *This detail of a dagger, dating from about 1550 B.C., was one of the treasures buried in a Mycenean shaft grave. It is made of bronze inlaid with gold and silver. On the blade, heavily armed hunters are shown attacking a pride of lions. A dagger of this type would have been used for ceremonial purposes, not for combat.*

in the burned ruins of its palaces. The cause of the destruction is again not known, but it may have been due to foreign invasion or war between the Mycenean cities. About four hundred years later, the great poet of ancient Greece, Homer, who lived sometime between 800 and 700 B.C., composed his epic work, the *Iliad*. This famous story of the siege of Troy, was based on legends handed down through the centuries. Many details of the world of the Mycenean warriors have been preserved in the verses of Homer.

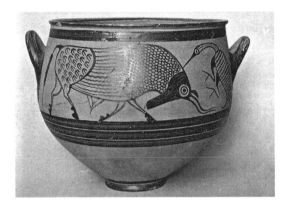

▲ *This Mycenean pottery bowl was found in Cyprus and was made between 1300 and 1200 B.C. It shows a long-beaked bird pecking an irritating insect out of a bull's coat. This must certainly have been something that the artist observed in real life.*

Mycenean Pottery

Mycenean pottery was produced in great quantities. Flasks, jars, jugs and goblets were decorated with designs based on plants, sea creatures and abstract patterns. Large bowls were painted with chariots or animals and made mainly for customers in Cyprus. ■

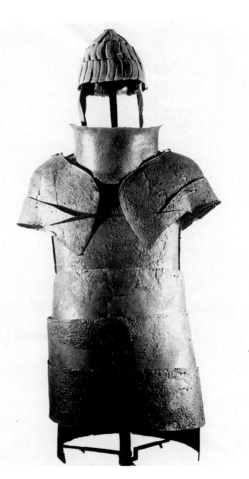

◀ *This Mycenean bronze armor dates from about 1400 B.C. In the Iliad, Homer describes Agamemnon, the leader of the Greek forces and king of the "stronghold of Mycenae," as being "armed in gleaming bronze, the greatest captain of them all."*

Assyrian Art: The Palace of the King, 900–600 B.C.

The Image of the King

The palace sculptures portrayed the Assyrian king as a dignified, brave and revered figure. Some showed him in his sacred role as the high priest of Ashur. In others, he was depicted in the company of his government officials. The king was also portrayed as a great war lord, bravely fighting with his troops on their campaigns. ◼

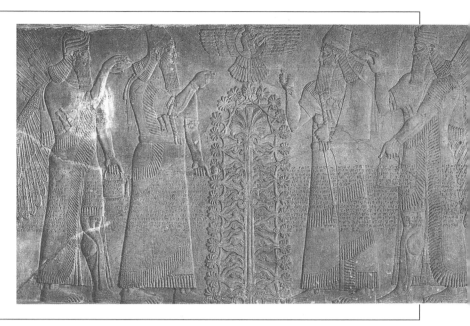

This stone sculpture, of about ▶ 865 B.C., decorated the wall behind the throne of Ashurnasirpal II. The king is shown twice, once on each side of a palm tree.

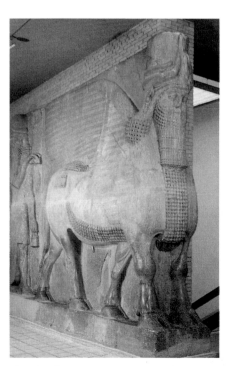

▲ *This large, stone monster from about 710 B.C. guarded the palace of Sargon II (who ruled 721–705 B.C.) at Khorsabad.*

Between about 1400 B.C. and 650 B.C., the ancient kingdom of Assyria expanded into a great imperial power. The Assyrian homeland was in northern Mesopotamia along the Tigris River. This was rich farming country open to attack from tribes living in the neighboring mountains of Kurdistan. To strengthen the security of their frontiers, the Assyrians, led by a series of strong and ambitious kings, embarked upon a campaign of expansion. They created, by threat or by force, an empire which, at its height, covered the whole of Mesopotamia, Syria and Palestine, from the west of Iran to the north of Egypt.

The king was the supreme power in the Assyrian state. He was absolute ruler, commander-in-chief of the army and high priest of Ashur, the national god. His prime duty was to protect and expand the land of Assyria.

Stone Guardians

Stone creatures guarded the entrances to Assyrian palaces. They were colossal figures that combined the characteristics of different species. These astonishing beasts were thought to have magical powers which would prevent the entry of evil spirits. ◼

This archeologist's reconstruction shows ▶ *the throne room of King Ashurnasirpal II (who ruled 883–859 B.C.) in the royal palace at Nimrud. It demonstrates what a splendid and colorful place it must have been. The walls were decorated with scenes showing the king hunting, leading his forces out on military expeditions and performing his royal duties. The sculptures were carved with an inscription in which Ashurnasirpal proudly recorded all the lands which he had conquered in the name of Ashur.*

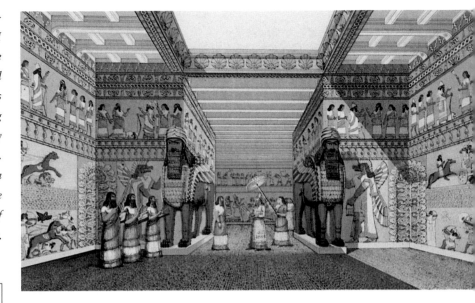

The Lionhunt of Ashurbanipal

In about 645 B.C., the palace at Nineveh was decorated with a series of sculptures showing King Ashurbanipal (who ruled 668–627 B.C.) engaged in the favorite royal sport of hunting lions. The royal lionhunts, staged outside the city walls, were great public spectacles. The lions, which would have been kept in captivity, were killed in an open space, encircled by soldiers. The hunts provided an opportunity for the king to display his courage and skill, essential qualities for an Assyrian monarch. ■

The Assyrian kings ruled from the various capital cities of Nineveh, Khorsabad and Nimrud. The core of the empire was the palace of the king. These palaces were magnificent showcases, designed to impress all who saw them with the power and splendor of Assyria.

The decoration of the royal palaces was organized by high-ranking officials under the king's supervision. The work was produced by an army of craftsmen, many of them captives from conquered lands.

Assyrian palaces were lavishly adorned with sculptures. Colossal statues of fearsome monsters stood on either side of entrance doors. The walls of palace rooms were decorated with low relief panels made of a type of stone called gypsum. They were vividly painted. Many of these have survived but practically all the color has disappeared. Above the panels, the plaster walls were decorated with paintings, but only a few fragments remain.

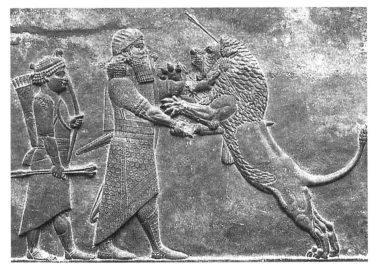

◀ *Palace sculptures depicted two principal themes. They illustrated both the nature of Assyrian kingship and the campaigns of the Assyrian armies. They glorified the king and the might of the Assyrian state. The king was portrayed in scenes demonstrating his courage, authority and the sacred character of his office. Other sculptures recorded in minute detail the campaigns of his forces as they ruthlessly overran enemy territories. In this relief sculpture, made in about 645 B.C., King Ashurbanipal is depicted killing a lion with his sword. The unfortunate creature has already been wounded by a volley of arrows.*

11 Assyrian Art: Images of Domination, 900–600 B.C.

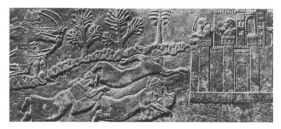

▲ *The stone reliefs from the palace of Ashurnasirpal II at Nimrud, show the king's campaigns along the Euphrates River. The reliefs are dated about 865 B.C. In this scene, Assyrian soldiers fire arrows against local inhabitants swimming across the river back to their city. One of the swimmers has been hit. The other two are using inflated animal skins to keep afloat. The ruler of the city and two women watch helplessly from the battlements.*

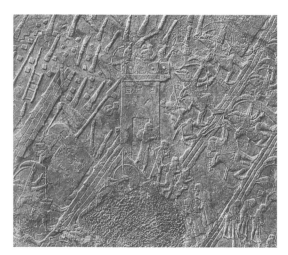

▲ *This wall sculpture from the series at Nineveh on the campaign against Lachish shows the attack on the gate tower at Lachish. The Assyrians have built ramps up which their forces advance. A siege engine is battering the tower. The people of Lachish hurl down arrows, stones and flaming torches. Some have been forced to abandon the city, and the Assyrians have hanged their leaders.*

Assyria was a military power, devoted to expanding its territories. The kings saw it as their duty to acquire new dominions for their national god, Ashur. They built their empire by a combination of diplomacy and conquest. Some states were prepared to acknowledge Assyrian domination without putting Assyria to the test. Those who resisted were ruthlessly crushed by the Assyrian armies.

The victorious campaigns of the Assyrian forces were commemorated in the relief sculptures on royal palace walls. The sculptures decorated public rooms where foreign delegations were received. They communicated a message and a warning. The message was that Assyria was invincible. The warning was that any resistance would lead to disaster.

The palace sculptures provided a detailed pictorial account of the Assyrian offensives. The Assyrian armies were probably accompanied by war artists who recorded their progress. The sculptures depicted the Assyrian troops on their long marches through enemy territory. They portrayed the massive force that the Assyrians used against those who opposed them. They showed how city after city was captured, its leaders slaughtered and its inhabitants forced into exile.

The palace sculptures did not provide the full picture. They represented the triumphs of the Assyrians and never their defeats. They were a form of political propaganda, whose purpose was to create an image of unassailable power.

By about 650 B.C., Assyria was in decline. Its resources were over-

The Assyrians in the Bible Lands

The countries of the eastern Mediterranean, Syria, Phoenicia, and the Old Testament lands of Israel and Judah, were repeatedly invaded by Assyrian armies. In 701 B.C., after Judah had rebelled against Assyria, the Assyrian king Sennacherib (who ruled 704–681 B.C.) stormed the Judaean city of Lachish. Sennacherib's records stated that he deported over 200,000 people from Judah to other parts of the Assyrian empire. The campaign against Lachish was shown in a series of relief sculptures which decorated the walls of Sennacherib's palace at Nineveh and which date from about 695 B.C. ■

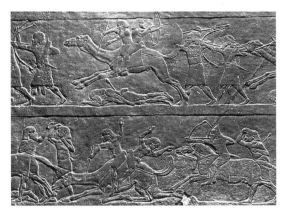

▲ *Assyrian troops are pursuing Arabs on their camel mounts in this wall sculpture from the king's palace at Nineveh (about 645 B.C.). One camel is wounded and collapses.*

War in the Desert

During the reign of King Ashurbanipal II (who ruled 668–627 B.C.), the Assyrians fought with tribes of camel-riding Arab nomads from the desert along the southern borders of Assyria. ■

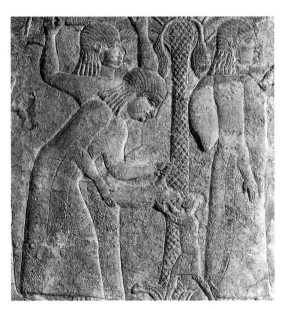

▲ *Assyrian sculptures contain touching human incidents amid the devastation of war. This wall relief, made between about 630 and 620 B.C. shows a captive Chaldean mother bending down to let her child drink.*

stretched by its huge empire and its government was weakened by struggles for the throne. Between 625 and 612 B.C., the cities of Assyria were destroyed by a military alliance between the Medes, a people from northwest Iran, and the Babylonians. They divided the Assyrian territories between them.

Following the destruction of its cities, Assyrian civilization gradually faded into oblivion. It was almost forgotten for over two thousand years.

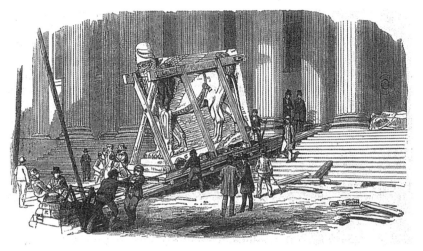

▲ *This engraving was published in a London magazine in 1852. It showed the arrival at the British Museum of a human-headed winged lion, excavated by Layard at the palace of Ashurnasirpal II at Nimrud.*

The Discovery of Assyrian Civilization

In the nineteenth century A.D., the ancient lands of Assyria formed a remote part of the Ottoman Turkish empire. The references to Assyria in the Bible aroused interest in trying to find the sites of Assyrian civilization. In 1842, Paul Emile Botta (1802–70), a French diplomat, discovered the remains of the palace of the Assyrian king Sargon II (who ruled 721–705 B.C.) at the site of the city of Khorsabad. Many sculptures from the palace were transported to France. They are exhibited in the Louvre in Paris. Between 1845 and 1852, the English archeologist Henry Layard (1817–1894) carried out excavations at the sites of the ancient cities of Nimrud and Nineveh. These sites revealed the remains of the palaces of successive Assyrian kings. The palaces contained huge numbers of sculptures. Layard estimated that he had uncovered nearly two miles/over three kilometers of sculptured reliefs in King Sennacherib's palace at Nineveh. Many sculptures excavated by Layard are now at the British Museum in London, England. ■

12 Babylonian Art: The City of Nebuchadnezzar, 600–500 B.C.

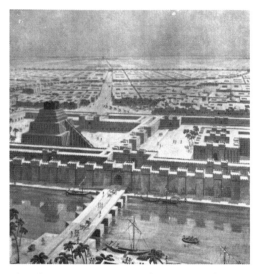

▲ *This reconstruction of ancient Babylon shows the bridge across the Euphrates and the great ziggurat, towering over the city.*

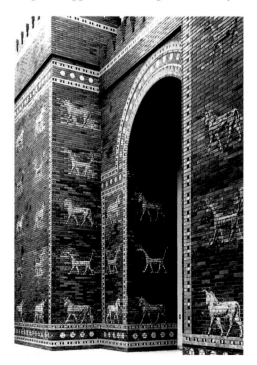

▲ *The Ishtar Gate was the main gate of ancient Babylon. It was built about 600 B.C. The outer entrance now stands reconstructed in the Staatliche Museum, Berlin.*

After the fall of Assyria, Babylon became once more a great imperial power. Under the rule of the Chaldean King Nabopolassar (who ruled 625–605 B.C.) and his son and successor Nebuchadnezzar II (605–562 B.C.), the Babylonians overran Syria, Phoenicia and Palestine. In 587 B.C., the city of Jerusalem fell after a long and terrible siege and many of the population were deported to Babylon.

Babylon had suffered centuries of destruction and neglect since the days of King Hammurabi. Now, Nabopolassar launched upon a massive building campaign to restore the city to its former glory. Nebuchadnezzar continued his father's work. He wanted to make Babylon a city that reflected the wealth and power of its empire and its king.

Babylon became a city of great temples and palaces. The colossal ziggurat, dedicated to the national god, Marduk, was rebuilt. The city was surrounded by a massive double wall, eleven miles/seventeen kilometers long, sixty-five feet/over nineteen meters high and eighty-five feet over twenty-five meters thick. A moat provided further protection. A huge bridge was constructed across the river Euphrates to connect the two halves of the city. Fortified gates, each dedicated to one of Babylon's gods, guarded the city entrances. The principal gate was named after Ishtar, goddess of love and war. A wide thoroughfare, the Processional Way, led through the Ishtar Gate and into the city.

The Babylonians developed a form of decoration, using a surface of brightly colored, glazed bricks. Both the Processional Way and the Ishtar Gate were embellished in this way with rows of animals, in

The Tower of Babel

The ziggurat of Babylon was the most impressive building in the city. It was called "the house of the foundation of heaven and earth" and stood in a walled enclosure. The ziggurat may have originated in the time of Hammurabi but was totally rebuilt by Nabopolassar and Nebuchadnezzar. The ziggurat was constructed in stories of decreasing size and it rose to the estimated height of 300 feet/90 meters. There were three flights of stairs which gave access to the upper levels. The high temple of Marduk was erected at the top. It is generally thought that the famous Tower of Babel in the Old Testament had its origins in this huge structure. ■

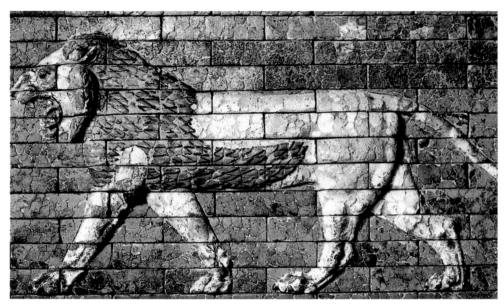

◄ *The Processional Way, constructed about 600 B.C., was the main avenue of Babylon, dedicated to the god Marduk. On its approach to the Ishtar Gate, it was bounded by high walls decorated with a long frieze showing a column of sixty majestic lions, striding one behind the other. Each of the lions was made up of forty-six different molded bricks, arranged in eleven rows. The lion was the symbol of the goddess Ishtar.*

The Ishtar Gate

The Ishtar Gate formed the main entrance into Babylon. It ran through the double wall of the city and consisted of an inner and an outer entrance with a passageway running between them. Each of the entrances was arched and was flanked by huge towers. The gate was decorated with images of the dragon, the creature associated with Marduk and the bull, the sacred animal of Adad, god of the sky. In the passageway which linked the inner and outer entrances of the Ishtar Gate, the excavators found a limestone block. The block was set into the walls and was engraved with this inscription addressed to Marduk:

Nebuchadnezzar, King of Babylon, son of Nabopolassar, the king of Babylon am I. The Gate of Ishtar I have built with blue glazed bricks for Marduk, my Lord. Massive bronze bulls and powerful snake-like beasts have I erected on its threshold....Marduk, sublime Lord, grant eternal life. ■

white, yellow and red, against a background of brilliant blue. The animals were constructed from molded bricks. All of this provided a splendid entrance into Babylon and a magnificent setting for the rituals of the Babylonian New Year Festival, when the images of the gods were paraded before the population.

Nebuchadnezzar II died in 562 B.C. Seven years later, Nabonidus (who ruled 555–539 B.C.), the last king of that dynasty, came to the throne. Such was Nabonidus's unpopularity that, in 539 B.C., when Cyrus the Great (who ruled 559–529 B.C. as king of Persia) attacked Babylon, the city is said to have surrendered without resistance. Two hundred years later, Babylon was conquered by the Macedonian Alexander the Great and became part of the Greek world.

After Alexander's death in 323 B.C., Babylon fell into desolation and ruin. It was all but forgotten until the end of the nineteenth century A.D. when excavators started work on its site.

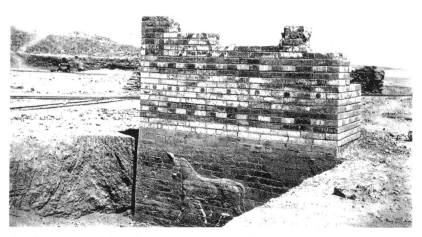

▲ *This is part of the Ishtar Gate emerging during the archeological excavations by a German team from 1899 to 1917.*

31

13 The Art of Achaemenid Persia: A Cosmopolitan Empire, 600–300 B.C.

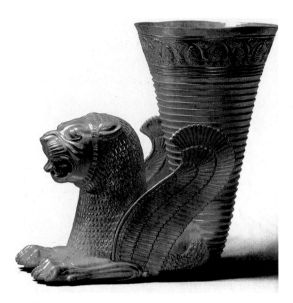

▲ *Spectacular finds of rich metalwork testify to the wealth and splendor of the Persian kings and nobility. This gold drinking vessel, called a rhyton, made in the shape of a lion, dates from about 500–400 B.C.*

It was Cyrus the Great, a member of the Achaemenid dynasty of Persian kings, who for the first time united the various peoples of ancient Iran. By about 525 B.C., under the rule of the Achaemenid kings, Persia had become the center of the greatest empire the world had seen. It included Asia Minor, now Turkey, Babylon, Afghanistan and Egypt.

The Persian kings drew huge riches from their vast domains. They exacted extensive tribute, in treasure or other objects of value, from their subject peoples. They also imposed a tax which had to be paid in silver.

Persian kings and nobles lived in great opulence. There was a considerable demand for luxury items such as jewelry, gold and silver vessels and ornaments. These were often very elaborate and produced to superb levels of craftsmanship.

The Achaemenid kings required a form of art and architecture which was appropriate to a great imperial power. They wanted impressive buildings decorated with magnificent sculptures. The Persians themselves, however, possessed little experience of large-scale projects. Many were nomads who moved from place to place and did not put up permanent buildings. They had developed a tradition in ornamental metalwork, used for items such as horse trappings and weapons. Many of these articles were made in decorative animal forms.

Although the skills the Persian kings required were not to be found in their homeland, they were present in abundance in the empire. So they called upon the peoples under their rule to assist them in their

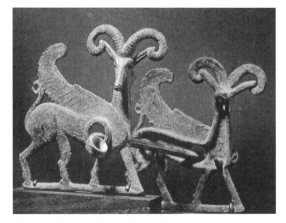

▲ *This bronze horse bit with decorated cheek-pieces is from Luristan and dates from about 750 B.C. The animals are mouflons or wild sheep.*

The Luristan Bronzes

Thousands of ancient bronzes have been discovered in vast burial grounds in the region of Luristan in the Zagros mountains of modern Iran. Most were bronze rein-rings, bits and harness fittings for horses. Many were made in the shape of animals. Unfortunately, many of the Luristan graves were plundered in the 1930s by people who were not archeologists, so vital information about the people who were buried there was lost. It is thought, however, that the bronzes belonged to tribes of nomadic horsemen. ■

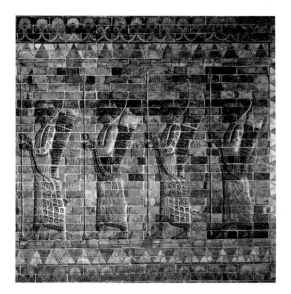

▲ *The royal palace of Darius I at Susa was decorated about 500 B.C. with panels of brightly colored, glazed brick of the type used in Nebuchadnezzar's Babylon. This is part of a panel which shows a line of archers from the royal bodyguard.*

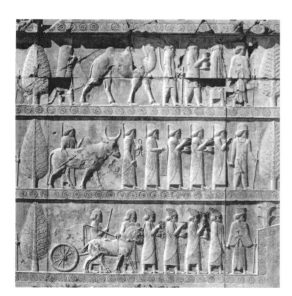

▲ *These relief carvings from a great stairway at Persepolis date from about 500 B.C. A delegation of Arians from western Afghanistan brings a tribute of bowls, a leopard skin and a camel. The Babylonians offer precious vessels, clothing and a humped bull. From Lydia, in Asia Minor, jewelry and a chariot pulled by two fine stallions are offered.*

A King's Pride

Darius I (who ruled 522–486 B.C.) erected a great palace at Susa. The building inscription lists with pride the skilled craftsmen from all parts of the Persian empire who took part in the work: *I am Darius, great king of kings....This is the palace which at Susa I erected....The stone-cutters who wrought the stone, those were Ionians and Sardians. The goldsmiths who wrought the gold, those were Medes and Egyptians....The men who wrought the baked brick, those were Babylonians....Says Darius the king: at Susa, here, a splendid task was ordered; very splendidly did it turn out.* ■

massive construction schemes. From far and wide builders and craftsmen poured into Persia to play their part in erecting and decorating buildings for the Achaemenid kings.

The building projects of the Achaemenids reflected the wealth and splendor of Persia at the height of its imperial power. Magnificent palaces were built at Persepolis and Pasargadae in southwest Persia, Susa in the west, Hamadan in the north and Babylon. At Persepolis, a magnificent architectural complex was constructed between 515 and 330 B.C. The buildings included royal palaces, state apartments and treasure stores. They were raised on an enormous terrace which was twelve feet/three and a half meters high.

The buildings at Persepolis were lavishly decorated with fine sculptures, carved in low relief. The sculptures portrayed the Persian kings on their imposing thrones, their loyal guardsmen and the officials of the royal court. The peoples of the empire were also depicted in all their rich variety. The sculptures of Persepolis celebrated the power and splendor of the Persian kings and the great cosmopolitan empire over which they ruled.

The Peoples of the Empire

The *apadana*, the principal audience hall of Darius I at Persepolis, was reached by magnificent stairways which were richly decorated with sculptures in relief. The sculptures depicted a procession of delegations from the lands of the Persian empire. In all, emissaries from twenty-three peoples are shown, each in national dress. The emissaries bring a rich variety of tribute from their native countries including precious vases, textiles, jewelry and animals. ■

14 Greek Sculpture: The Quest for Reality, 700–450 B.C.

Making a Stone Statue

A stone statue is carved from a rectangular block of stone. The sculptor draws the outlines of the statue on all four sides of the block. The surplus stone is then chipped away with a punch. Chisels are used to shape out the figure. Finally, tool marks are removed with a rasp and the surface smoothed with abrasive powders. It could take between six months and a year to make a life-size figure. The design has to be fixed before cutting away at the stone. Stone, especially marble, is heavy and breaks easily unless it is supported. Experimenting with new poses is not easy. ■

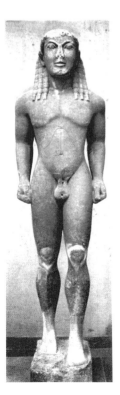

◀ *This* kouros *dates from about 600 B.C. It embodies the stiff, frontal pose and the symmetry of this type of statue. Although these characteristics give the figure an appearance of power and gravity, at the same time, they make it less realistic. The sculptor has not depicted anatomical details in a naturalistic manner but by ridges and grooves carved on the surface of the stone.*

After the collapse of Mycenean civilization in about 1200 B.C., Greece embarked upon a period of poverty and isolation which lasted for about 300 years. The population fell dramatically and the cities were deserted. The people lived in small, scattered communities. Many left the mainland and settled on the west coast of Asia Minor, now Turkey and in the Aegean islands. Overseas trade ceased almost completely. During these difficult times, the level of Greek culture declined and the skill of writing was forgotten. There was little demand for art or architecture.

Gradually, prosperity returned and the population began to rise. Overseas commerce revived. Through trade, the Greeks became aware of the achievements of other civilizations which they adapted to their own purposes. In Egypt they saw monumental stone statues which served as models for their own sculptors. They derived an alphabet from the people of Phoenicia, on the eastern Mediterranean. By about 650 B.C., Greece had acquired the wealth and the skills to become one of the great civilizations of the ancient world.

The position of artists in ancient Greece was very different from their situation in other civilizations. In Mesopotamia and Egypt, artists served the king or the priesthood. They had very little freedom in their work and they were expected to produce art in traditional forms. There was little scope for change.

In Greece, however, patronage of the arts was not concentrated in a wealthy and powerful ruling class. Artists worked for a wide section of the community. They had the freedom to experiment and to develop new ideas. Changes could take place in Greek art in a way that

The *Kouros*

Life-size stone statues were made in Greece from about 650 B.C. Early statues of men are known as *kouroi*, from the Greek word, *kouros*, meaning youth. *Kouroi* retained the rectangular outline of the block from which they were carved. The figures stood erect and facing front, the left foot forward and the arms held close to the body. The two sides of the body were absolutely symmetrical. *Kouroi* were erected as grave statues or as an offering to one of the gods. The way the *kouros* developed illustrates the progress in Greek art toward greater naturalism. ■

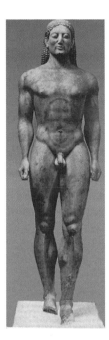

◀ *This* kouros *dates from about 530 B.C. It seems far more lifelike than the older one. The face and the body are rounded and seem more fleshy. The muscles are more realistic. However, the pose remains stiff and unnatural.*

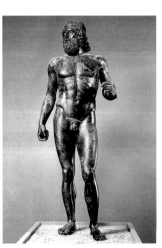

This bronze ▶ *warrior probably dates from about 450 B.C. He would originally have held a shield. His stance is very different from the rigid, symmetrical pose of the* kouros. *The head is turned slightly and the right side of the body is higher than the left. The subtle twist of the figure gives it an impression of movement and vigor.*

Making a Bronze Statue

The technique of bronze hollow-casting had originally come from Egypt. To make a bronze statue, the Greek sculptor first made a model of the figure from clay. The model was coated with a thin layer of wax. Fine features could be carved or sculpted into it. It was then covered with a clay mold and heated until the wax melted and drained away. Molten metal was then poured into the empty spaces. When the metal had cooled, the mold was broken away and the golden, bronze statue revealed. ■

Bronze Statues

By about 500 B.C., the Greeks had perfected the art of producing full-size statues from bronze. From this time, most Greek statues were bronze rather than stone. Sculptors could now experiment with different poses and were not restricted by the shape of the marble block. Bronze is much lighter than stone and does not need to be supported like stone. Bronze gave artistic freedom to Greek sculptors resulting in a new quality of realism in their statues. ■

was not possible in the civilizations of the east.

The fundamental theme of Greek art was the human body. Early Greek artists struggled with the problems of depicting human anatomy. Their aim was to represent the figure as realistically as possible. Within two hundred years, between about 650 and 450 B.C., Greek sculptors had mastered the portrayal of human physique. They achieved a perfection of form which continues to be admired as the ideal of human beauty.

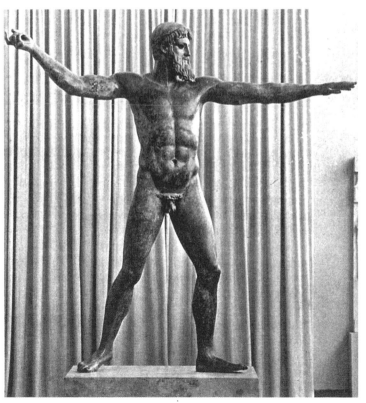

▲ *This bronze figure of about 460 B.C. probably depicts the Greek god Zeus. The pose would have been impossible in stone unless the arms were supported underneath. The figure, hurling an unseen thunderbolt, stands almost seven feet/over two meters high.*

35

15 Greek Art: Unity and Rivalry in Art, 700–450 B.C.

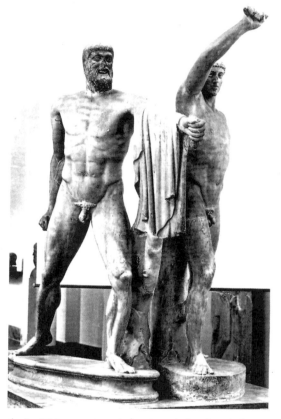

▲ *In 514 B.C., two Athenians helped to bring about the downfall of the tyrant, Hippias. In about 477 B.C., the Athenians erected a bronze statue to commemorate the deed. The original statue no longer exists. This is a Roman copy.*

Ancient Greece was not a single nation as it is today. There were many independent states or *poleis* (the singular form is *polis*) with different systems of government. Each *polis* was under the control of a ruling city. The *poleis* were scattered over mainland Greece, the Aegean and the west coast of Asia Minor, or Turkey. Between about 750 B.C. and 600 B.C., the Greeks founded many overseas colonies. There were Greek cities in the south of Italy, Sicily, southern France and Cyprus and settlements around the Black Sea.

The people of these communities were linked by their race, language and religion. They all considered themselves to be Greek but, at the same time, intense rivalries existed between the *poleis*. Greek art showed both the spirit which unified the ancient Greeks and the divisions which separated them.

Athenian Democracy

Some Greek *poleis* were ruled by a wealthy faction of the community. Others were governed by a dictator or tyrant. In 510 B.C., the city of Athens, in southeastern Greece, overthrew its tyrant, Hippias. A democratic system was established enabling every adult male citizen to take part in government. Athenians were immensely proud of their democracy, which was imitated by many other Greek states. Their pride was symbolized by a famous statue which was known as the Tyrannicides or tyrant killers, commemorating a political assassination that contributed to the overthrow of the tyranny and the founding of the democracy. ■

The inhabitants of the island of ▶ Siphnos spared no expense when they erected their splendid treasury about 525 B.C. at Delphi. The building was made entirely of marble and lavishly adorned with carved and painted decoration. This is a section of the carved marble frieze depicting the battle between the gods and the giants.

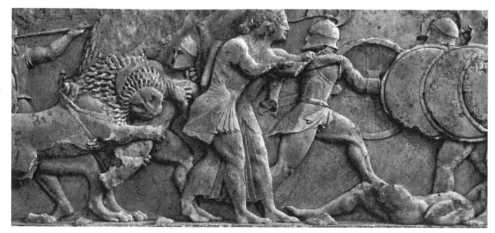

The Labors of Heracles

The twelve labors of Heracles were depicted in relief sculptures which decorated the temple of Zeus at Olympia. The labors were tasks which required superhuman strength and guile. Once Heracles had completed them, he became immortal. The eleventh labor was to obtain the golden apples which had been a wedding gift to the goddess, Hera. Heracles was helped by the Titan, Atlas, whose task it was to support the weight of the heavens on his shoulders. He was the father of the Hesperides, the four nymphs who guarded the apples. Atlas went to fetch the apples while Heracles took over his burden. ■

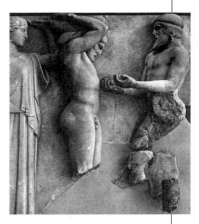

This relief sculpture, from the Temple of Zeus at Olympia (about 460 B.C.), shows Heracles ▶ *holding up the heavens, his face and body tense with enormous strain. The goddess Athena is helping him. Atlas has just returned, bringing with him the golden apples of the Hesperides.*

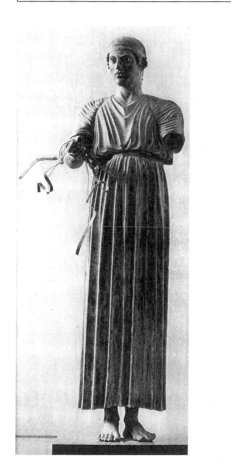

▲ *The Greek games included races, wrestling, boxing, the five events of the pentathlon and horse and chariot races. This bronze statue of a charioteer was erected at Delphi, in about 475 B.C. Originally, the figure was shown in a chariot drawn by four horses, to celebrate victory in the chariot race.*

The great sanctuaries at Olympia in southern Greece and Delphi in central Greece were places of pilgrimage for visitors from all parts of the Greek world. A sanctuary was an area dedicated to the worship of a particular god. Olympia was consecrated to Zeus, the king of the gods. Delphi was sacred to Apollo, the god of music and prophecy. Delphi was the site of the most important Greek oracle. Suppliants believed that prophecies or advice could be obtained from the god through the oracle by means of mysterious rituals.

Visitors to Olympia and Delphi brought valuable gifts for Zeus and Apollo. These offerings were stored in treasuries which were small buildings consisting of one room with a porch in front. Each was built by an individual *polis.* As treasuries were often used as a way of displaying local pride and wealth, many were made from costly materials and were elaborately decorated with sculpture and painting.

A new temple was built at Olympia, between about 470 B.C. and 460 B.C., in honor of Zeus. It was richly adorned with sculpture. The two porches were decorated with reliefs showing the mythical labors of Heracles. Heracles, the son of Zeus, was the greatest of the heroes of ancient Greece and was venerated throughout the Greek world.

At both Olympia and Delphi, athletic games formed part of great religious festivals. All the Greeks shared a passion for athletics. According to tradition, the games at Olympia began in 776 B.C. They were the greatest of the athletics competitions of ancient Greece and were the forerunners of the modern Olympic Games.

Success at the games brought enormous prestige to both the winner and his city. The victor was entitled to erect a statue to commemorate the event. Both Olympia and Delphi were once crowded with these figures. They have virtually all disappeared although many of the pedestals on which they were placed remain.

16 Greek Art: Vases, Familiar Images, 700–450 B.C.

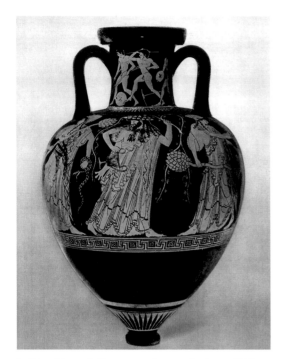

▲ *On this red-figure amphora of about 510 B.C., Dionysus, the god of wine, is carousing with his followers. He is crowned with ivy and brandishes a wine cup with two handles called a* kantharos *and a vine branch.*

Types of Vases

Greek vases were produced in many shapes and sizes. The design depended on what the vase was used for. Food or wine was stored in a tall jar with two handles, called an *amphora*. The Greeks drank their wine mixed with water in a large bowl known as a *krater*. Olive oil was an important substance in ancient Greece. It was used for cleaning the body as well as for cooking and light. Oil was expensive. In order to make sure that none was wasted, it was poured from a narrow-necked flask called a *lekythos*. ■

In Greece, as in the ancient world in general, pottery was an essential item. Pottery was used for storing food, carrying water and for eating and drinking. In ancient Greece, pottery vessels were often decorated with painted designs. These painted vessels are usually called vases. Thousands of Greek vases have survived, showing what enormous numbers must have been made.

Pottery was manufactured in many Greek cities. By about 550 B.C., Athens had become the most important center of pottery production in the whole Mediterranean. The pottery industry was concentrated in the area of the city known as the *Kerameikos*. Athenian vessels were well proportioned and skillfully made. They were decorated with finely painted figures. Vases produced in Athens were exported throughout the Greek world and to Spain, North Africa and Asia Minor, or Turkey.

Until about 500 B.C., most Athenian vases were painted with black figures against a red background. This type of vase decoration is known as black-figure. After that time, the fashion changed to red-figure work. This consisted of red figures against a black background. Sometimes other colors, such as white and purple, were added. As in Greek sculpture, vase painting shows how artists gradually learned to portray the human figure in a more realistic way.

Athenian pottery was produced for a wide market. To be successful, the Athenian vase painter had to decorate his vases with pictures that appealed to popular taste. The vases were painted with scenes that would have been instantly recognized and understood. These images were attractive because they were familiar and because they conformed to the accepted views of society.

Many scenes on Greek vases record everyday life in ancient Athens. They cast light on the differences between the position of men and women. An Athenian woman's life was extremely restricted compared with a man's. A middle-class woman was expected to spend most of her time in the home and many Greek vases portray women at work on their household tasks, such as making cloth, fetching water and looking after children. In contrast, Athenian men appear to have enjoyed a lively social life and vases often depict their drinking parties with guests lying on couches, entertained by dancers and musicians. The riotous aftermath of these occasions is frequently represented.

Greek vases were also decorated with incidents from myth. A great

The Women of Athens

Athenian women suffered many disadvantages. They had no political rights. Athenian democracy was confined to men. Women took no part in the government of the city. The law did not allow them to buy and sell property. Society excluded them from many occupations. There is no evidence that women worked as sculptors and it is unlikely that many were employed as potters or painters. Athenian women were given little education except for training in household responsibilities. ■

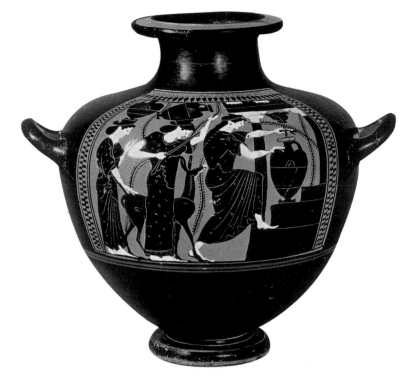

▲ *Three women draw water from a fountain in this painting on a black-figure* hydria, *a vessel used to hold and carry water, of about 510* B.C. *The women use a* hydria *to collect their water.*

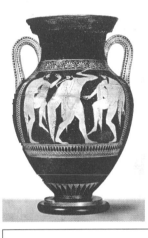

◀ *These Athenian men, painted on a red-figure amphora of about 510* B.C., *have had too much to drink. One of them is carrying a* kantharos *which, hopefully, is not yet empty.*

number show scenes involving the gods. Since many types of Greek vases were associated with drinking wine, Dionysus, the god of wine, was a popular subject. The best loved of all Greek legends was that of the Trojan War, another favorite theme for vase painters.

Black-figure and Red-figure Vases

Athenian vases were made from local clay that became orangey-red when fired in a potter's kiln. If a vase was painted with a mixture of clay and water, the painted parts turned shiny black after firing. In black-figure vases, the figures were painted and their details were engraved with a pointed tool. The rest of the vase was left blank. On red-figure vases, the background was painted, the figures left unpainted and details were painted with a brush. ■

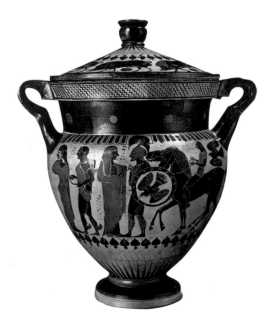

◀ *Scenes from the Trojan War were frequently depicted on Greek vases. This black-figure* krater *was made about 530* B.C. *It shows Hector, the great warrior of Troy as he bids farewell to his wife. Next to them stand Paris, prince of Troy, with Helen. Homer tells us in the* Iliad *that Paris and Helen's love affair sparked off the Trojan War.*

17 Greek Art: Athens Supreme, The Parthenon, 450–430 B.C.

The Parthenon remains an impressive ▶ *spectacle in spite of its ruined state. The colonnade, central building, architrave and band of* metopes *can clearly be seen in this recent picture.*

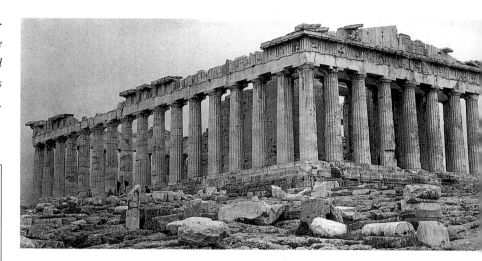

The Greeks Triumphant

Greek sculptors often used stories from myth to symbolize real events. The *metopes* on the Parthenon consisted of panels which were sculpted in high relief. On one side of the building, the *metopes* depicted a battle between Greeks and centaurs. Centaurs were savage creatures who were half horse, half man. The ancient Greeks would have understood these sculptures as symbolizing their conflict with the Persians. They saw this struggle as a battle between Greek civilization and Persian barbarism. ∎

From about 550 B.C., Greece was threatened by the ambitions of Persia, under the rule of the Achaemenid kings. By 540 B.C., the Persians were masters of the Greek cities of Asia Minor, modern Turkey. In 490 B.C., they launched an unsuccessful invasion against the Greek mainland. In 480 B.C., the Persians tried again. This time, they were successful. Terrible destruction was wrought upon Athens. The Greeks then rallied, led by the Athenians and the Spartans from southern Greece. By 479 B.C., the Persians had been defeated. In 449 B.C., peace was signed. By that time, Athens, ruthlessly using her navy against her fellow Greeks, had become the wealthiest and most powerful state in Greece.

As soon as peace was declared, the Athenians embarked upon a

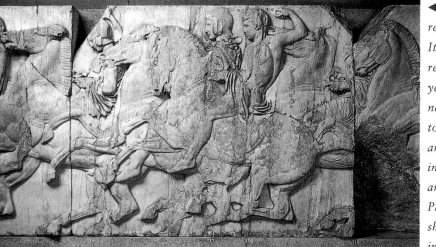

◀ *The Parthenon frieze, sculpted in low relief, was over 500 feet/150 meters long. Its subject was the Great Panathenaia, a religious festival in Athens held every four years to honor Athena. On this occasion, a new woolen robe was taken in procession to the Acropolis and presented to an ancient statue of Athena. The procession included horsemen, musicians, city elders and sacrificial animals. This section of the Parthenon frieze, made in about 440 B.C., shows some of the horsemen riding in procession.*

▲ *The great procession depicted in the Parthenon frieze ended in the presence of the Greek gods. In this section, the bearded Poseidon talks with the youthful Apollo who is seated beside his twin sister, Artemis, the goddess of hunting and the moon. The figures present an impression of perfect calm and beauty associated with many of the sculptures of the period.*

Damage of Time

The Parthenon remained in use as a temple to Athena for nearly a thousand years. In the fifth century A.D., it was converted by the early Christians into a church. Both the structure and the sculptures were badly damaged in the process. An explosion in the seventeenth century caused further destruction. In 1806, the British diplomat, Lord Elgin, purchased most of the surviving sculptures from the Turks, who occupied Greece at the time. The sculptures were stripped from the building or collected from the site. They were brought to England and sold to the British government. The Elgin marbles, as they are called, can be seen today in the British Museum in London, England. Greece has requested their return on the basis that the Turks had no right to sell them. The request has been refused. The Elgin marbles are in better condition that the sculptures still in place on the Parthenon, which have been damaged by air pollution. ■

massive construction project to restore their war-damaged city. They were led by the great statesman, Pericles. The most important part of the work was the rebuilding of the upper city or Acropolis. The Acropolis was a sacred area, devoted in particular to Athena, the patron goddess of Athens. Most of the buildings on the Acropolis had been destroyed by the Persians. The most crucial task was the erection of a new temple dedicated to Athena Parthenos (Athena the Maiden). It came to be known, therefore, as the Parthenon.

The Parthenon was built between 447 and 432 B.C. The temple was constructed entirely of white marble. It consisted of an oblong building, with two rooms and a porch with six columns at each end. The larger room housed a colossal statue of Athena. The statue was about forty feet/twelve meters high. It was made of gold and ivory over a timber framework. The smaller room was used as a treasury. The building was surrounded by a colonnade of forty-six columns.

The Parthenon was remarkable for the richness of its sculptural decoration. The themes of the sculpture glorified Athena and celebrated the Athenians' pride in their achievements. Each of the pediments or roof gables contained a group of statues. One group represented the contest between Athena and the sea-god, Poseidon, for the ownership of Attica, the Greek province ruled by Athens. The other group depicted the birth of Athena. Over the architrave, the marble beam above the colonnade, there ran a band of sculptured panels known as *metopes*. Scenes from Greek mythology were depicted, symbolizing the Greek victory against the Persians, in which the Athenians had played a leading part. A long, sculptured frieze decorated the exterior of the central building, depicting the Athenians in solemn procession at their greatest religious festival held in honor of Athena. In spite of the ravages of time and pollution, the Parthenon is still a glorious symbol of the city of Athens at the height of its power.

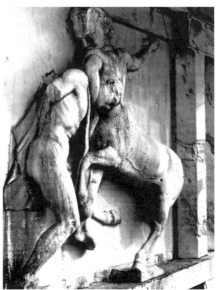

◀ *This* metope *from the Parthenon, dating from about 445 B.C., depicts the struggle between a Greek youth and a centaur. The youth endeavors to free himself from the grasp of the centaur, who rears up on his back legs like a horse. The high relief carving intensifies the dramatic effect. This* metope *is still in place on the Parthenon and shows how air pollution has eaten away at the stone of the building.*

Greek Art: Art and Death, 450–390 B.C.

The painter ▶ has portrayed the dead woman sadly bidding her young maid farewell on this funeral lekythos of about 440 B.C. The girl holds a casket of jewels belonging to her mistress. The painted color on the maid's dress has faded away, revealing the sketch beneath.

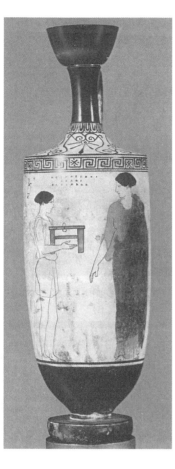

Funerary art, connected with the burial of the dead, was an important source of work for artists in ancient Greece. A type of vase called a funeral *lekythos* (the plural form is *lekythoi*) was often used as a grave offering. *Lekythoi* were filled with sweet-smelling oil and placed in the tomb as a gift for the person who had died. The dead were frequently commemorated by marble tombstones which were carved in relief and placed over the grave.

After about 450 B.C., a new style of funeral *lekythos* emerged in Athens. It was decorated with colored figures painted on a white background. Various colors were used, including red, yellow, green, blue and mauve. This variety of decoration is called white-ground. White-ground vases were less durable than other types of pottery, so they were unsuitable for everyday use. However, they were ideal for use in the grave and it became increasingly common for funeral

Funeral lekythoi ▶ *were decorated with images connected with death. Scenes of mourning or leave-taking, and gods or spirits associated with the dead appeared. The figures often possessed a quality of calm and dignity which was appropriate to funerary art. This funeral* lekythos *made in about 420 B.C., shows the spirits, Sleep and Death carrying away the body of a young warrior. The soldier's helmet has been left behind and hung on his tomb. The tomb is decorated with red fillets or woolen bands, attached to tombs as a sign of mourning.*

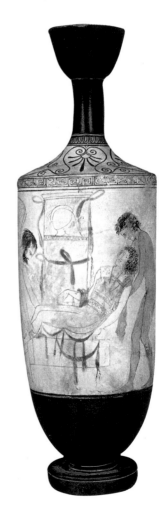

White-ground Pottery

The technique used to make white-ground vases differed from those employed for other types of Greek pottery. The exterior of the vase was covered with a white slip or mixture of clay and water. The figures were outlined on this surface and then colored. The colors were not applied until after the vase had been fired in the kiln. This made the decoration on white-ground vases less stable than the painting on black-figure and red-figure pottery. On most surviving funeral *lekythoi*, the colors have largely faded, leaving only the outline of the figures underneath. ■

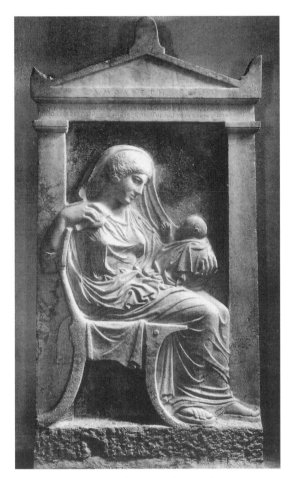

▲ *This marble tombstone of an Athenian woman called Ampharete and her grandchild dates about 410 B.C. The child died young. The image of Ampharete is idealized and makes her look much younger than she actually was. She gazes tenderly at the baby, who reaches up towards her. In her hand, she holds a bird, symbolizing the soul of the departed. The sculptor has skillfully depicted Ampharete's body beneath the drapery of her clothing.*

Memorials for the Departed

Athenian tombstones were often sculpted in high relief, frequently portraying the dead person standing or sitting before the doorway of a building. This may have symbolized their entrance into the next world. ∎

lekythoi to be decorated in this more colorful way.

From 431 to 404 B.C., Athens and her allies were involved in the disastrous conflict which is known as the Peloponnesian War. The war was instituted by a confederacy of Greek states which considered themselves to be threatened by the great power of Athens. The confederacy was led by the city of Sparta, which had long been Athens's greatest rival. Sparta was the leading state of the Peloponnese, the area of mainland Greece south of the Isthmus of Corinth.

The Peloponnesian War resulted in complete defeat for Athens. By the time it ended, a third of the population of Athens had perished from the plague, the land had been ravaged and the navy lost. Sparta now became the leading power in Greece.

With the outbreak of war, commissions for Athenian sculptors became increasingly rare. Most of the sculpture needed for the new buildings in the city had been completed. Many sculptors went to work abroad. Sadly, the one type of work which was plentiful was funerary sculpture. From about 430 B.C., substantial numbers of sculptured tombstones were produced in Athens. It was in this field, rather than in great public works, that the sculptors of Athens now practiced their craft.

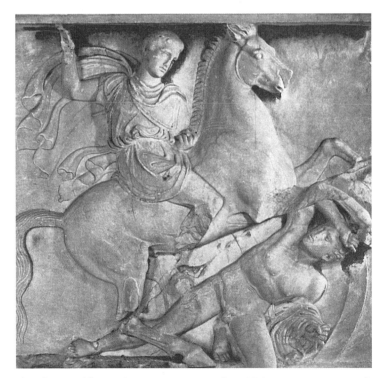

▲ *This marble tombstone was erected in 394 B.C. in memory of Dexileos, an Athenian cavalryman who died in battle at the age of twenty. He is portrayed as a heroic warrior, riding down the enemy. This style resembles that in which the horsemen on the Parthenon frieze are portrayed.*

19 The Art of Hellenistic Greece: The Greek World Expands, 323–30 B.C.

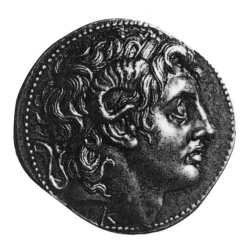

▲ *This silver coin from Thrace, dated about 300 B.C., bears a profile portrait of Alexander. Alexander is depicted in the guise of a god with the horns of a ram springing from his temples. The horns were a sign of divinity.*

The defeat of Athens in the Peloponnesian War did not bring peace to Greece. The Greek cities continued to compete for power. By about 350 B.C., Sparta was in decline and the other Greek states were weak and divided. Against this background the kingdom of Macedon, in northeast Greece, rose to supremacy under the rule of Philip II (who ruled 359–336 B.C.), its able and ambitious king.

At the battle of Chaeronea, in 338 B.C., Philip crushed the last resistance among the Greek cities and Macedon became master of all Greece. Two years later, Philip was assassinated. He was succeeded by his son, known to history as Alexander the Great who ruled from 336–323 B.C. He was just twenty years old when he became king.

Alexander the Great

A new style of royal portrait was invented for Alexander based upon the representations in Greek art of mythical heroes such as Heracles. An idealized image of the king, stressing his youth and heroism, was created. The image of Alexander became famous. It appeared on statues and coins. Many Hellenistic kings had themselves portrayed in the same style as Alexander. In this way they associated themselves with Alexander's huge reputation and achievements. ■

The Great Altar at Pergamum

The city of Pergamum in Asia Minor was one of the most important centers of the Hellenistic world. The kings of Pergamum tried to make their city the equal of Athens at the time of the Parthenon. They spent lavishly on public buildings and sculpture. In 180 B.C., a colossal altar was erected on the acropolis or upper city. It was dedicated to Zeus in gratitude for victory against the Gauls. The altar was decorated with a sculptured frieze, over 350 feet/95 meters long, which was carved in very high relief. The sculpture depicted the battle between the giants and the gods, a popular subject in Greek art. The frieze was produced in a very ornate style. ■

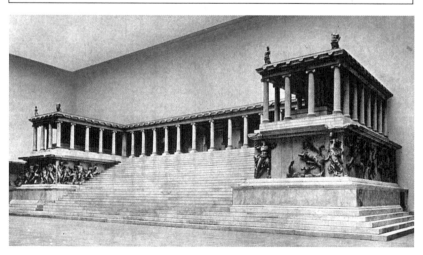

▲ *The altar of Zeus at Pergamum built between about 180 B.C. and 150 B.C., included architectural features such as a colonnade and staircase. A marble frieze ran around the foot. The altar has been reconstructed in the Staatliche Museum, in Berlin, Germany.*

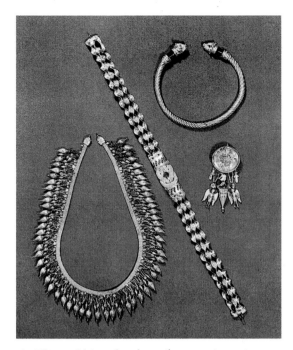

▲ *This gold jewelry dates from various times during the Hellenistic period. Since gold does not deteriorate with age, it looks as if it has only just been made.*

This bronze statue of a boxer of about 100 B.C. is an example of the realistic style of Hellenistic art. In earlier Greek art, athletes had been idealized. This muscular, battered boxer sits exhausted after his last bout. He is still wearing his gloves. His face is scarred and his nose broken. The sculptor has made him a figure to be pitied. ▼

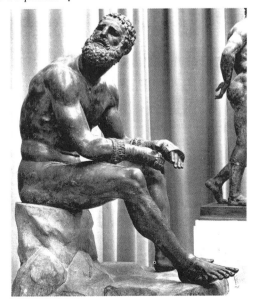

An Opulent Lifestyle

The wealthy classes of the Hellenistic world delighted in splendor and luxury. Their palaces and houses were decorated with magnificent furniture, paintings and mosaics. Silver tableware replaced painted pottery for eating and drinking. An enormous range of gold jewelry was produced including earrings, necklaces, bracelets, clasps and tiaras, often embellished with tiny figures or animal heads. ■

Alexander was one of the most celebrated generals of all time. He was determined to avenge the Persian treatment of the Greeks by destroying the Persian empire. He did so in a series of brilliant military campaigns. By 330 B.C., the last Achaemenid king of Persia was dead. Alexander was ruler of territories stretching from Greece to Afghanistan.

Alexander's objective was not merely conquest. His aim was to spread Greek civilization throughout his newly acquired territories. He founded seventy new towns in Asia and many were named Alexandria for him. The towns shared many of the features of Greek cities and were organized in the same way.

Alexander died of fever in Babylon, in 323 B.C., at the age of thirty-two. After his death, his generals fought for control of the empire and, eventually, a number of separate kingdoms emerged. The most important were Egypt, Syria, Macedonia and Pergamum in Asia Minor, now Turkey. These kingdoms continued to be heavily influenced by Greek civilization. For this reason, the word, Hellenistic (from the Greek word *Hellas*, meaning Greece), is used to describe their culture.

The spread of Hellenistic society resulted in a huge demand for the work of Greek artists and craftsmen. The new Hellenistic kings of Asia were their most important patrons and instigated the building of scores of new cities and temples. They commissioned portraits and elaborate works of public sculpture. The royal courts also created a fashion for luxury goods, such as silverware and jewelry, which spread among the wealthy upper and middle classes.

Greek artists travelled freely throughout the Hellenistic world. Their exposure to new cultures and ideas brought about great changes in their work. Artists tackled new themes and worked in a wide range of styles. In royal portraits, they tended to idealize the subjects. Other Hellenistic art presents people realistically, with all their physical imperfections. Many Hellenistic kings commissioned public sculpture in a flamboyant style. Whatever style they adopted, the artists of the Hellenistic period attained the highest levels of craftsmanship in their work.

20 The Art of Phoenicia and Carthage: Maritime Empire, 900–150 B.C.

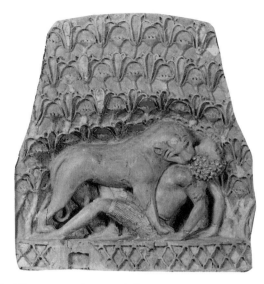

▲ *This ivory plaque of about 730 B.C. was found in an Assyrian palace at Nimrud. It shows a lioness pouncing upon an Ethiopian. The man's hair is made from tiny ivory pegs, the size of pinheads. The figures are depicted against a background of lilies.*

Artists in Ivory

The Phoenicians were experts in the art of ivory carving. They originally used tusks from Syrian elephants. By about 800 B.C., this species had been hunted to extinction and the Phoenicians had to obtain ivory from Indian or African elephants. The Phoenician craftsmen specialized in producing small plaques used to decorate expensive pieces of furniture. The plaques were sometimes covered with gold leaf and encrusted with colored stones. Thousands of Phoenician ivories have been found in the royal palaces of Assyria, seized as war booty or made by Phoenician captives. ■

Ancient Phoenicia was situated on the eastern coast of the Mediterranean. It covered an area roughly equivalent to modern Lebanon. Phoenicia consisted of a number of independent cities, each of which was the center of a small kingdom. The most important of these cities were Tyre, Sidon and Byblos.

Art for Trade

Phoenician art was produced for commercial purposes. It was traded over a vast area and had to appeal to a wide variety of customers. Phoenician craftsmen used popular Egyptian, Syrian and Assyrian designs only for decoration and without regard for their original meaning. They adjusted the patterns to suit the type of object being produced. ■

The Phoenicians were sailors and merchants. They were forced to seek opportunities beyond the shores of their narrow strip of land, hemmed in by mountains. The period from about 1000 B.C. to 700 B.C. was the golden age of Phoenician civilization when they established a wealthy and far-flung commercial empire.

Phoenician prosperity depended on the lucrative international metal trade. Phoenician merchants dealt in copper from Cyprus, silver and tin from Spain and gold from Africa. They traded, in return, a wide range of goods which were manufactured in the workshops of the Phoenician cities.

Phoenician craftsmen specialized in the production of small luxury items. Their workmanship was renowned. They made ivory plaques, metal bowls and statuettes, jewelry and glassware. The Phoenicians

◀ *The Phoenician craftsman brought together motifs from Egyptian and Assyrian art, to decorate this gilded silver bowl in about 650 B.C. In the center, Egyptian soldiers trample over the enemy. Around the edge is depicted a sequence of events in the day of an Assyrian prince.*

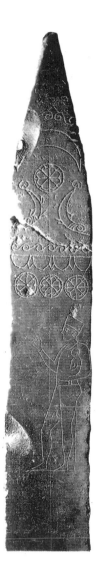

◄ *This stone* stele *was erected in about 300* B.C. *in the* tophet *at Carthage. It is engraved with the figure of a priest, carrying a child for sacrifice.*

The Signs of Sacrifice

The Carthaginians retained many aspects of Phoenician religion, including the practice of child sacrifice. This custom continued in Carthage long after it had died out in the homeland. The ritual was performed at times of great danger to the state. It was carried out in a sacred precinct, or *tophet*. The victims were dedicated to Baal Hammon and Tanit, supreme god and goddess of Carthage. After death, the bodies were cremated and the ashes buried in funerary urns. The burial place was often marked with an inscribed stone *stele*. Many of these *stelae* have been found in the *tophets* at Carthage and in other areas under Carthaginian rule. ■

developed their own form of art by borrowing from the art of surrounding civilizations. The foreign design themes were adapted to produce a distinctive Phoenician art.

By about 800 B.C., the Phoenicians had founded a wide network of colonies to protect their trading routes, in Cyprus, Sicily and Sardinia, and as far west as southern Spain and the coast of North Africa. The most important of the colonies was the city of Carthage, in North Africa. By about 600 B.C., Carthage had superseded the cities of the homeland to become the leading power of the Phoenician world.

The Carthaginians took over the Phoenician trading empire and expanded it. They maintained many Phoenician traditions. The production of luxury goods continued in Carthage although the standard of workmanship was not nearly so high. The Carthaginians adopted the Phoenician custom of dedicating *stelae*, or standing stones, to the gods. Many *stelae* have been found in sanctuaries where sacrificial rites were practiced.

By about 300 B.C., Carthage had come under threat from the rise of Rome and war became inevitable. In 264 B.C., the first of three conflicts between Rome and Carthage broke out that are known as the Punic Wars. Punic is from the Latin word for Phoenician. In 218 B.C., the Carthaginian forces, led by their great general, Hannibal (who lived from 247 to about 182 B.C.), made their famous march from Spain, through France and over the Alps, to Italy. They were accompanied by thirty-seven war elephants but only three survived the journey.

Although Rome suffered the worst defeats of her history at the hands of Hannibal, she was finally victorious. When, in 146 B.C., the wars ended, Carthage had lost her empire, the city had been burned to the ground and the inhabitants killed or taken into slavery. Rome became mistress of the western Mediterranean.

Hannibal was a member of an eminent Carthaginian family that became rulers of the Spanish dominions. They issued coins bearing family portraits, making plain their power. This silver coin from Spain struck in about 220 B.C., *shows Hannibal (left) in the guise of a Hellenistic ruler. An African war elephant appears on the other side of the coin (right). Elephants were used in battle, to charge the troops of the enemy.* ▼

21 The Etruscans: Italian Art Before the Romans, 800–300 B.C.

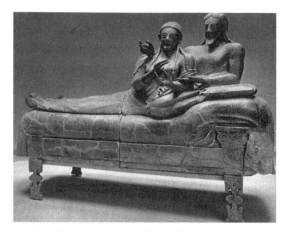

▲ *This husband and wife, reclining together at a banquet, appear on a terracotta sarcophagus from Cerveteri dating about 500 B.C. The women of Etruria were allowed greater freedom to appear in public than those of ancient Greece.*

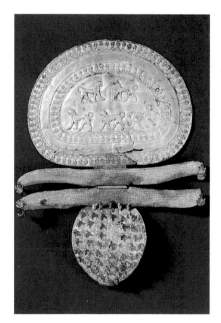

▲ *This gold clasp from Cerveteri was made in about 700 B.C. in the orientalizing style. It is decorated with lions and lotus flowers. The clasp was found in the tomb of an Etruscan noblewoman. It was used to fasten her cloak.*

Between about 800 and 300 B.C., the Etruscans, a people living in central Italy, developed a remarkable civilization. Their homeland, ancient Etruria, was bounded to the north by the Arno River, to the east and south by the Tiber River and to the west by the Tyrrhenian Sea. Part of this region is today called Tuscany, a name which recalls its ancient inhabitants.

Etruria was rich in natural resources and was famed for its fertile farmlands. Deposits of copper and iron attracted Greek and Phoenician trading ships. Contact with the great civilizations of Greece and the east was very important for the growth of Etruscan civilization and the development of its art.

During the period from about 700 to 600 B.C., the art of the eastern Mediterranean exerted a great influence upon the Etruscans. Imports from Egypt, Syria and Phoenicia flooded into Etruria, and Etruscan craftsmen produced their own versions of these objects. The Etruscan art of this period is called orientalizing because it derives from the orient or east. Many objects decorated in this style have been found in the rich tombs of the time.

After about 600 B.C., Greek art became the most important influence in Etruscan art. There was close contact with Greek colonies in southern Italy and Sicily. Vast numbers of Greek artifacts were imported into Etruria and Greek craftsmen came to work there. Many features of Etruscan sculpture and pottery were inspired by Greek art. Hardly any large paintings have survived from ancient Greece itself, but we can get some idea of what they would have looked like from Etruscan tomb paintings.

Although the Etruscans were influenced by Greek art, they did not simply imitate it. They developed original art forms in many fields. Their sculptors produced distinctive work in terracotta, or baked clay.

Etruscan Sculpture

The Etruscans were accomplished sculptors. They produced sculpture mainly in terracotta. Statues and reliefs were used to decorate temples and as funerary art, to commemorate the dead. The figures often show the influence of Greek sculpture but are unmistakably Etruscan. ■

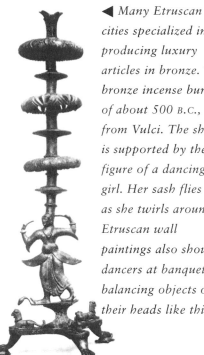

◄ Many Etruscan cities specialized in producing luxury articles in bronze. This bronze incense burner, of about 500 B.C., is from Vulci. The shaft is supported by the figure of a dancing girl. Her sash flies out as she twirls around. Etruscan wall paintings also show dancers at banquets, balancing objects on their heads like this.

Art from the East

Between about 700 and 600 B.C., members of the Etruscan aristocracy were buried in elaborate tombs, magnificently attired and surrounded by objects of gold, silver, pottery and bronze. Many artifacts were made in an orientalizing style, inspired by decorative goods imported from Phoenicia and other eastern countries. The items often incorporated exotic animals and plants in a way typical of art from the east ■

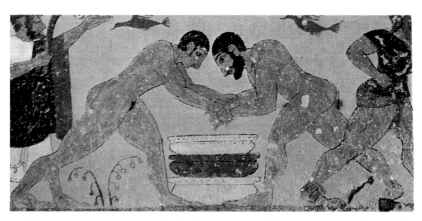

▲ *This Etruscan painting, dating from about 530 B.C., decorated a tomb in the cemetery outside the city of Tarquinia. It depicts a wrestling match between two hefty contenders. An umpire, carrying a crook, oversees the fight. The bowls on the ground are probably prizes.*

Cult of the Dead

The Etruscans believed that the spirit lived on in the tomb after death. Many Etruscan tombs were painted with scenes which depicted feasting, hunting and sports. The Etruscans believed that the paintings would enable the deceased to enjoy these pleasures after death. ■

A characteristic type of black pottery called *bucchero* was developed. Etruscan bronzeware and jewelry were renowned. Etruscan products were exported to many countries including Greece, Asia Minor, or Turkey, Spain and North Africa.

One striking aspect of Etruscan civilization is the importance attached to the burial of the dead. Etruscan tombs were built like underground houses and huge burial grounds, resembling cities of the dead, were constructed outside many Etruscan towns.

At its height, the influence of the Etruscans extended over most of Italy, including Rome. Flourishing cities, such as Cerveteri, Tarquinia and Vulci, developed near the Tyrrhenian coast. Many other important Etruscan towns grew up inland.

After about 500 B.C., Etruscan power was in decline. They were attacked by the Greeks from the south and the Celtic tribes in the north. The rise of Rome marked the end of Etruscan civilization. By about 100 B.C., all the cities of Etruria had been conquered or absorbed and the Etruscans became part of the Roman world.

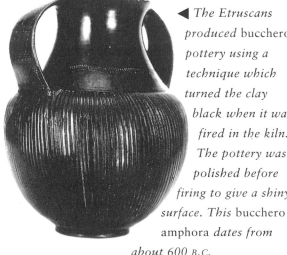

◄ The Etruscans produced bucchero pottery using a technique which turned the clay black when it was fired in the kiln. The pottery was polished before firing to give a shiny surface. This bucchero amphora dates from about 600 B.C.

23 Roman Art: Roman Splendor, 500 B.C.–300 A.D.

▲ *The huge amphitheater that later became known as the Colosseum, was built between about 72 and 80 A.D. It consisted of an oval-shaped arena, with seating for 50,000 people. The Colosseum provided a magnificent setting for the bloodthirsty sports enjoyed by the Romans. Popular entertainments included wild-animal hunts and fights to the death between gladiators.*

The Imperial Baths

Public baths were an important part of Roman life. In Rome alone, there were more than 800 of these buildings. The imperial baths, built by various Roman emperors, were colossal vaulted constructions. They contained different rooms for cold, warm and hot water as well as swimming pools and areas for exercising and resting. They were lavishly decorated with marble, statues and mosaics. They provided a luxurious meeting place for the Romans of both sexes. ■

As the power of Rome expanded throughout the Mediterranean, there were far-reaching changes in Roman life. Wealth flowed in from the empire and Rome was transformed from a country town into a great imperial capital. Once the Romans had come into contact with the splendors of the Greek world, they developed a taste for luxury and ostentation. Many Romans criticized this trend which, they felt, was out of keeping with the best Roman traditions.

From the time of Augustus, Roman emperors were responsible for massive building projects in the capital. Rome was beautified with magnificent squares, palaces and temples. Many emperors paid for civic buildings with their own money. Great imperial baths were constructed for communal use. A vast amphitheater (later known as the Colosseum) was erected, in which the Romans could watch spectacular public entertainments.

The imperial family and wealthy classes lived in considerable splendor. Their homes were elaborately decorated and furnished. The walls were adorned with exotic marbles or painted frescoes. Ceilings were richly ornamented with plasterwork. Brightly colored mosaics covered the

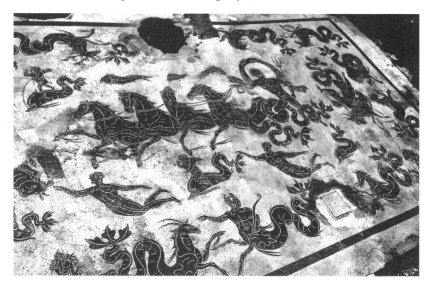

▲ *The floors of Roman baths were often decorated with black and white mosaics. This example, dating from about 139 A.D., is from the Baths of Neptune at Ostia, the harbor town for Rome. The subject of the mosaic is highly appropriate. It shows the sea god, Neptune, being drawn through the water by four lively seahorses. The god is escorted on his way by swimmers, dolphins and other creatures of the sea.*

This floor mosaic comes from a splendid ▶ *country villa built for the emperor Hadrian (who ruled 117–138 A.D.) at Tivoli, near Rome, in about 135 A.D. It shows a fierce battle between centaurs and wild beasts. The artist has made the scene as exciting as possible by including a lion, a tiger and a leopard in the picture.*

Roman Mosaics

Mosaic was a popular method of decoration which the Romans learned from the Greeks and used for both their homes and public buildings. Mosaics were assembled from small pieces of colored stone, or *tesserae*, which were pressed into a bed of soft mortar to form decorative patterns or pictures. Mosaics were usually applied to floors and sometimes used for walls and ceilings. ■

This stone relief, from a mosaic artist's tomb at Ostia (third to fourth century), shows two men cutting tesserae *for mosaics. Two others carry away the stone.* ▼

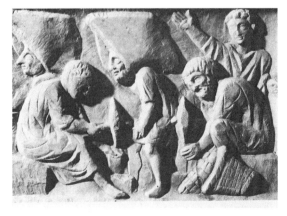

floors, and statues filled the rooms and gardens. Much of this work was inspired by Greek art and carried out by Greek craftsmen.

The Roman middle classes tried to follow aristocratic tastes by making their own homes appear as grand as possible. By tragic chance, a vivid record of Roman middle-class life in the provinces has been left to us. In 79 A.D., the catastrophic volcanic eruption of Mount Vesuvius, in the Bay of Naples, resulted in massive loss of life. The area was covered with volcanic particles, ash and mud. These substances acted as a preservative, protecting the towns and settlements beneath until they were excavated in the eighteenth century.

The excavations at one of these sites, Pompeii, revealed a complete Roman town which had been home to 10,000 people. There were public buildings, shops and workshops, and large numbers of private dwellings. Numerous household objects were recovered. Many of the houses at Pompeii were decorated with wall paintings. When they were first discovered, the colors were as bright as if they had just been painted. These paintings were created over a period of about 300 years and show how the style of Roman art changed.

From about 50 A.D., it became fashionable to decorate ▶ *walls with painted panels. This room at Pompeii was painted about 63 A.D. The left panel shows the child Hercules (Heracles to the Greeks) demonstrating his enormous strength by strangling two serpents. On the right, King Pentheus, the enemy of Bacchus, is attacked by the Bacchantae.*

24 Roman Art: Roman Faces, 500 B.C.–300 A.D.

Freed Slaves

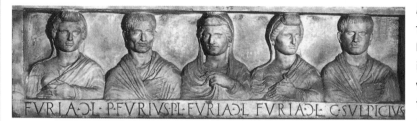

▲ *During the late republic and early empire, freed slaves were buried in roadside tombs on the edges of Roman cities. Life-size portraits, carved in marble, were set into the walls of the tombs. This portrait, dated about 13 B.C., shows a family of former slaves by the name of Furius.*

Libertini, or slaves who had been freed by their masters, played an important part in Roman society. Their freedom was granted in return for money or labor. Former slaves were permitted to take up a profession or to enter trade. Many prospered, and some even rose to influential positions at the imperial court. Freed slaves often became rich enough to commission private funeral monuments for themselves and members of their family. ■

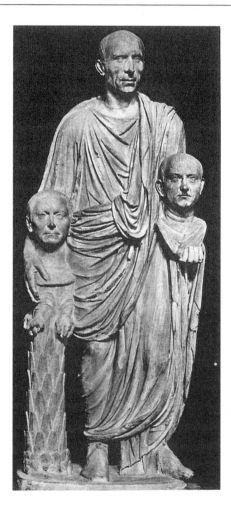

We can come face to face with the Romans in a way which is not possible with any other people of the ancient world. This is because the Romans were fond of having their portraits produced in sculpture and many of these portraits have survived. This passion for portraiture applied to every social class, from the imperial family down to freed slaves.

By about 100 B.C., the Romans had developed their own distinctive type of portrait sculpture. Its outstanding feature was that it was utterly realistic and did not shrink from reproducing every physical imperfection. Etruscan portraits, such as those on funeral sculpture, were an important influence in the development of this branch of Roman art. Another factor was the Roman tradition of commissioning marble portraits of family ancestors. These portraits were based on death masks, made of wax or plaster. They were produced as portrait busts, which included the chest and shoulders as well as the head.

◄ *This marble statue of the early first century A.D., shows a Roman nobleman, dressed in a toga. He proudly exhibits the portrait busts of his ancestors, probably his father and grandfather. The man's pose recalls the custom of carrying ancestral death masks in the funeral processions of Roman aristocrats. This tradition was a way of publicly associating the family with its distinguished past. All three heads on the statue have the realistic appearance of Republican portraits.*

The New Hercules

The emperor Commodus (who ruled 180–192 A.D.) led an extravagant and dissolute life with a mind totally unbalanced by power. He shocked Rome when he fought in the gladiator's arena. His life was ended when he was murdered. Commodus saw himself as the divine reincarnation of the mythical hero Hercules and had himself portrayed in that guise. His arrogant and profligate personality comes through clearly in his portrait. ■

In this ostentatious marble bust of about 190 A.D., Commodus is portrayed as ▶ Hercules. He wears the hero's lionskin headdress. He holds the club of Hercules in his right hand. In his left hand, he is holding the golden apples of the Hesperides, a reference to one of the labors of Hercules.

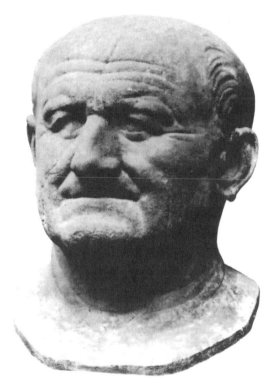

▲ In his portraits, the emperor Vespasian chose to be shown as he actually was and not idealized as a god or a youthful hero. This marble head dates from about 75 A.D. It shows a vigorous, kindly and keenly intelligent man in his sixties. The emperor is depicted with all the usual characteristics of middle age. His forehead is furrowed, he has bags beneath his eyes and his mouth is sunken

As the realistic style of portraiture was at its height before the beginning of the empire, it is usually described as Republican. Its influence continued into the imperial period. Republican portraits usually represented middle-aged or elderly men, who were often distinguished citizens or politicians. The subjects were shown in a plain, direct style that did not seek to flatter or idealize them. The characteristic features of old age, such as baldness, wrinkles and lines, were emphasized rather than avoided. To the Romans, old age was associated with experience and wisdom rather than decrepitude and was therefore something to be celebrated.

During imperial times, the emperor set the fashion in portraits. Many emperors chose to be portrayed in a heroic style which had its roots in Greek art rather than in the native traditions of Italy. On the other hand, it suited some emperors to have themselves depicted in the forthright manner associated with Republican portraits. In each case, the choice depended on the public image which the emperor wished to create.

A Down to Earth Emperor

Vespasian (who ruled 69–79 A.D.) came from a modest family background and not from the nobility. He was a tough soldier, and a capable and benevolent emperor. He put the state on a sound financial footing and brought discipline to the Roman army. He wished to represent himself as an upright and practical ruler, completely devoid of any pretensions. He returned, therefore, to the Republican style of portraiture, which associated him with traditional Roman values of this type. ■

25 Early Islamic Art: Art and Faith, 600–1000 A.D.

The religion of Islam was founded in western Arabia by the Prophet Muhammed, who was born in the city of Mecca, in about 570 A.D., and died at Medina in 632 A.D. The followers of Islam are called Muslims. According to Islamic belief, Muhammed received a series of revelations from God, through which he was informed of His divine plan for humanity. Shortly after Muhammed's death, the revelations were collected and copied into the Koran, the holy book of Islam. Islam is a monotheistic religion, sharing with Judaism and Christianity a belief in the one God, creator of the universe.

The new faith established by Muhammed and his supporters soon grew into a powerful spiritual and political force. An Islamic state was established in Medina in 622 A.D., so that the divine plan, revealed to Muhammed, could be put into practice on earth. Islam spread by conquest. By about 750 A.D.,

The Art of Handwriting

Fine handwriting was greatly admired in the Islamic world, where literacy was high. Many varieties of decorative script were developed. The oldest form of Islamic calligraphy is called Kufic, since it is thought to have been invented in the city of Kufa in Iraq. Kufic script had rectangular letters, which were suitable for carving inscriptions in stone as well as for writing on parchment. ■

This leaf ▶ from a Koran was written in Kufic script on vellum about 900 A.D. The chapter heading, illuminated in gold, is decorated with a palm-tree design.

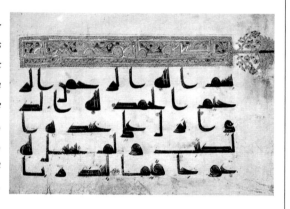

The Place of Prayer

Mosques were the most important Islamic buildings and were to be found in every Muslim town. Although there were various types of mosque, they usually consisted of a courtyard and a covered hall for prayer. This layout was based on the plan of Muhammed's house in Medina. The worshippers faced towards Mecca, the birthplace of Muhammed, the direction being marked by a niche in the wall called the *mihrab*. Every mosque was built with a minaret, or tower, from which a crier or *muezzin* called the faithful to prayer. ■

The courtyard of the Great Mosque of Damascus, built between 705 ▶ and 715 A.D., is surrounded on three sides by roofed arcades, with the prayer hall on the fourth side. The mosque had the first minarets in the Muslim world. One of them rises in the background.

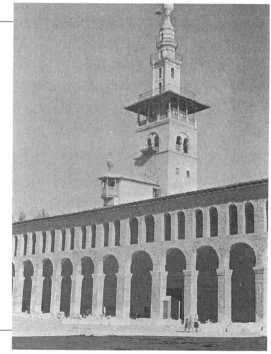

Designed for Worship

The interior of the mosque was designed as a setting for contemplation and prayer. Marble, mosaic, wood and plaster were applied to produce rich decorative effects. The decorative elements were used to create an impression of harmony and space. Finely worked inscriptions brought the words of the Koran constantly before the eyes of the congregation. ■

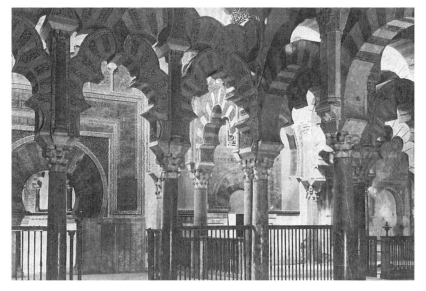

▲ *The mosque at Cordoba, in southern Spain, was begun in 785 A.D. and extended several times during the next two hundred years. It was one of the largest mosques in Islam, capable of holding 5,500 worshippers. The interior was richly decorated with gold and mosaics, Kufic inscriptions and floral arabesques.*

southern Spain and North Africa in the west, and Mesopotamia, Persia and Afghanistan in the east, were all under Islamic rule.

The arts flourished in the Muslim world, as did learning and culture of every description. Many forms of Islamic art were closely connected with the Muslim faith. Calligraphy or handwriting was considered the highest form of art, because the written words of the Koran transmitted the word of God, as revealed to Muhammed. The most important task of the calligrapher was the production of copies of the Koran. Inscriptions from the Koran also formed an important element in the decoration of mosques, Islamic places of prayer.

Many Muslims interpreted Islamic teaching as forbidding the representation of living creatures. Accordingly, no images of human beings or animals were permitted in religious art of the Islamic world, although they were allowed in secular or non-religious art. This led to the development of a rich tradition of abstract, or non-representational, art in Muslim countries. Islamic artists evolved intricate decorative forms which were based on plant forms or geometric shapes. These are known as arabesques.

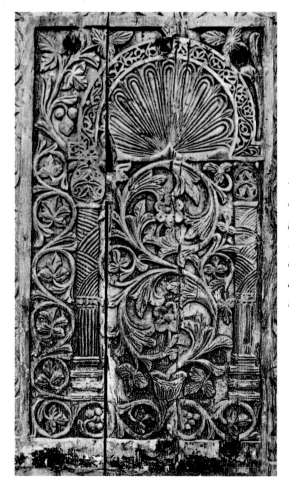

◄ *This wooden console (780 A.D.) from the al-Aqsa Mosque, Jerusalem, is elaborately carved with arabesques which are based on plant motifs.*

26 Early Islamic Art: Caliphs and Merchants, the Secular Arm of Islam, 600–1000 A.D.

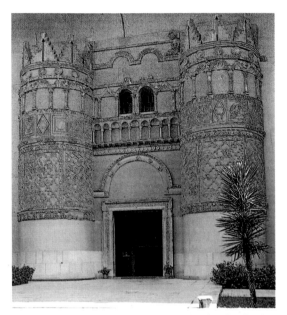

▲ *The palace at Qasr al-Hayr al-Gharbi, built between 726 and 727 A.D., near Palmyra, served principally as a hunting lodge for the caliph. The gateway was covered with intricate decoration in stucco or plasterwork.*

After Muhammed's death, one of his trusted colleagues was chosen as his caliph or successor. The Islamic state was ruled by a series of caliphs, from the capital at Medina, until 661 A.D. In that year, following a bitter struggle, the Umayyad dynasty assumed power and moved the capital to Damascus, in Syria.

The Umayyad caliphs were renowned for their love of luxury and pleasure which contributed, in part, to their downfall. They were great patrons of the arts, building for themselves elaborate desert palaces which were decorated in the most sumptuous manner. The decoration frequently included images of humans and animals, forbidden in the religious art of Islam.

In 750 A.D., the Umayyad rulers were overthrown by the Abbasids, a rival faction, who replaced them as caliphs. By this time, the period of military expansion was over, and an era of peace and prosperity began in the Muslim world. In 766 A.D., a new Islamic capital was founded in Mesopotamia. The capital was built at the site of a village named Baghdad, meaning "Gift of God". By the beginning of the ninth century, Baghdad was probably the largest city in the world. The mosque and the caliph's palace were situated in the Round City. The area containing these buildings was enclosed by massive circular

Desert Palaces

The palaces of the Umayyad caliphs were often large-scale architectural complexes, with areas for different purposes. The palaces were the centers of large country estates as well as serving as princely residences. They also fulfilled the role of *caravanserais*. The buildings were equipped with comforts such as bathhouses and cool underground rooms, a relief during hot weather. Many contained their own mosque. The Umayyad palaces were lavishly decorated, with mosaics, wall paintings and plasterwork providing an effect of the utmost luxury. ■

The palace at Khirbat al-Mafjar was built between 724 and 743 A.D. at Jericho, and was exceptionally ▶ *luxurious, even by the standards of the Umayyad rulers. It contained a huge audience hall with a central dome, flanked by a swimming pool on one side and by hot baths on the other. The palace was richly decorated with sculptures in stucco. This figure of a dancer dates from about 743 A.D.*

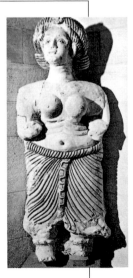

Islamic Pottery

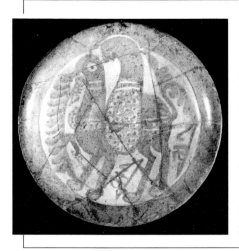

Islamic potters were renowned for the quality and variety of their wares. One of their most successful innovations was a type of pottery called lusterware. This type of pottery has a metallic sheen on the surface. This surface effect was obtained with a thin coating of silver and copper, which was fired at a low temperature. The popularity of lusterware rapidly spread throughout the Islamic world. The technique was used to produce decorative wall tiles as well as tableware. ■

◀ *This strange creature, carrying a palm leaf in its beak, appears on a lusterware plate of the ninth century from Samarra, in Mesopotamia.*

▲ *Islamic craftsmen were expert in working silver, brass and bronze. This bronze ewer, from Cairo, dates from about 750* A.D.

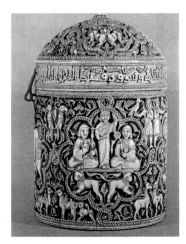

walls, which also contained the dwellings of government officials.

The peace and unity of the Islamic world under Abbasid rule provided ideal conditions for the development of long-distance trade. Camel caravans of merchants travelled from Spain in the west as far as the borders of China in the east. *Caravanserais*, or roadside stations, provided them with food and shelter along the way. Sea trade also thrived, with voyages to China, India and east Africa, from ports on the Red Sea and the Persian Gulf.

Trade and prosperity encouraged a great flowering of Islamic art. Throughout the Muslim world, skilled craftsmen produced fine pottery and glass, elaborate carpets and textiles, and decorative metalwork. These artifacts were traded in exchange for a wide variety of goods, including silk from China, spices from India, and gold and ivory from Africa.

From the ninth century, the vast Abbasid empire began to disintegrate. Different provinces broke away to become independent. A separate Muslim state was established in southern Spain, with its capital at Cordoba and flourishing Islamic centers at Seville and Granada. Egypt, its capital at Cairo, similarly became self-governing. The Islamic lands in Persia and central Asia fragmented in the same way. Muslim peoples continued, nevertheless, to be united by the bond of their common Islamic culture.

◀ *Ivory carving was a flourishing craft in the city of Cordoba, in Spain. The craftsmen there specialized in producing ivory caskets, intricately carved with plants, animals and figures from court life. Most were probably intended for members of the royal family and the nobility. This casket (964* A.D.*) depicts a king and queen with their musician and falconer.*

Bibliography

Aldred, C. *Egyptian Art*. New York and London: Thames and Hudson, 1980.

Aries, Philippe and Duby, Georges (eds.). *A History of Private Life: From Pagan Rome to Byzantium*. Cambridge, Mass. and London: The Belknap Press of Harvard University Press, 1987.

James, D. *Islamic Art: An Introduction*. New York and London: Hamlyn, 1974.

Oates, J. *Babylon*. New York and London: Thames and Hudson, 1979.

Poulton, Michael. *Life in the Time of Augustus and the Ancient Romans*. Austin: Raintree Steck-Vaughn, 1992.

Poulton, Michael. *Life in the Time of Pericles and the Ancient Greeks*. Austin: Raintree Steck-Vaughn, 1992.

Ramage, N. H. and Ramage, A. *The Cambridge Illustrated History of Roman Art*. New York and Cambridge, England: Cambridge University Press, 1991.

Rice, David Talbot. *Islamic Art*. New York and London: Thames and Hudson, 1993.

Roaf, M. *A Cultural Atlas of Mesopotamia and the Near East*. New York and Oxford: Facts On File, Inc., 1990.

Strong, D.E. *The Classical World*. New York and London: Hamlyn, 1967.

Woodford, S. *The Art of Greece and Rome*. New York and London: Cambridge University Press, 1982.

Acknowledgements

My thanks are due to the following members of the History of Art Department of the Victoria University of Manchester:

Dr. Suzanne B. Butters
Dr. Livia Morgan
Dr. Tom Rasmussen

Glossary

acropolis The highest elevation in an Ancient Greek city, usually fortified.

amphitheater A circular or oval Roman building open to the sky, containing an arena encircled by tiers of seats.

amphora A large jar with two handles, used in Greek and Roman times to store and transport liquids such as wine or olive oil.

arabesque Intricate abstract style of patterned decoration based on geometrical and plant forms, used in Islamic art.

centaur A mythical creature with the head, arms and torso of a man and the lower body and legs of a horse.

citadel A fortified town or part of a town.

console An ornamental bracket used to support a wall fixture.

cuneiform Form of writing in ancient Mesopotamia, using wedge-shaped signs incised into wet clay tablets.

fresco A type of painting on wet plaster.

frieze A horizontal band of decoration.

Hellenistic era The period between the death of Alexander the Great in 323 B.C. and the establishment of Roman rule in Greece and Asia Minor (modern Turkey), when Greek culture predominated throughout the eastern Mediterranean.

kantharos A two-handled drinking vessel.

krater A large bowl, used for mixing wine and water.

Kufic A form of Arabic script.

lapis lazuli A blue semiprecious stone which can be used for decoration or ground up to make a pigment for painting.

lekythos A narrow-necked jug with one handle, used in Greece as a container for oil.

luster A shiny, metallic surface coating on pottery.

mosaic A pattern or picture assembled from small pieces of colored stone or tile pressed into soft mortar.

mummy A body that has been preserved through a process of embalming and wrapping.

oracle A priest or priestess at a shrine dedicated to a god who can pass on the god's answers to the questions of the faithful.

parchment An animal skin prepared for writing or painting.

pentathlon An event at the Greek games involving five different activities: long jump, discus, javelin, sprint and wrestling.

portrait bust A sculpture of a person's head, shoulders and chest.

relief A technique used in sculpture in which the subjects are raised from a flat background.

rhyton A drinking vessel.

sarcophagus A stone coffin, often elaborately decorated.

sphinx A mythical creature with the body of a lion and the head of a man or a hawk. It is used in Egyptian art as a symbol of the pharaoh.

stele (plural stelae) An upright stone slab engraved with a design or an inscription.

stucco Ornamental plaster work.

terracotta Fired, or baked, earthenware clay.

toga A draped one-piece outer garment worn only by Roman citizens.

vizier A high official of government.

ziggurat A Mesopotamian temple-tower.

Photo Credits

Acropolis Museum: 41 left
Al-Agsa Mosque, Jerusalem: 57 bottom
Arabic Museum, Cairo: 59 center
Archeological Museum, Heraklion: 23 bottom, 28 top
Archeological Museum, Naples: 52 bottom
Archeological Museum, Teheran: 32 top
Berlin State Museum, Staatliche Museum: 13 top (head), 30 bottom, 31 top, 44 right, 53 top
Trustees of the British Museum: 8 left, 10 right, 19 top, 25 center and left, 26 left, 27 left, 28 top and bottom, 29 top, 40 left, 42 right, 44 left, 45 top, 46 top, 49 top left
Candia Museum, Crete: 22
Capitoline Museum, Rome: cover, 50 left, 54 bottom, 55 right
Chester Beatty Library, Dublin: 56 top
Chicago Institute, Univ. of Chicago: 30 top
Cook, B.F.: 40 right
Delphi Museum: 36 bottom, 37 left
Deutsches Archaologisches Institut, Athens: 41 right
Egyptian Museum, Cairo: 14 left, 15 top, 16 right and left, 17 right and left, 18 top, 20 top and bottom
Freud Museum, London: 9 top
Gerster, Dr George: 8 right
copyright © Hunt, John: 24
Illustrated London News: 29 center

Instituto de Valencia de Don Juan: 47 bottom
Istanbul Archeological Museum: 13 top (body)
Kerameikos Museum, Athens: 43 left and right
Khirbat al-Mafjar, Jordan: 58 right
Layard, A.H.: 27
Louvre, Paris: 11 right, 12 right, 13 bottom, 33 top, 59 top and bottom
Martin von Wagner Museum, Wurzburg: 39 bottom
Musée du Bardo, Tunis: 47 top
Museo Archeologico di Villa Giulia, Rome: 46 right
Museo Nazionale di Villa Giulia, Rome: 39 top, 45 bottom, 48 top
Museum of Fine Art, Boston: 42 left
Museum of Iraq, Baghdad: 9 bottom, 11 left, 12 left
Museum of Nanphia, Greece: 25 right
National Museum, Athens: 35 top and bottom
National Museum, Crete: 25 top
National Museum, Damascus: 58 left
Naples National Museum: 36 top
Ny Carlsberg Glyptotek, Copenhagen: 55 left
Olympia Museum: 37 right
Ostia Museum: 52 right, 53 left
Philadelphia, University Museum: 10 left
Private Collection: 14 right, 19 bottom, 21 right, 23 center, 32 bottom, 33 bottom, 49 top right, 51 top and bottom, 52 left, 56 bottom, 57 top
Regional Museum, Reggio: 35 center
Staatliche Museum Antikensammlung, Munich: 38, 39 center
Vatican Museum: 48 bottom, 49 bottom, 50 right, 54 top

Index

Abbasids, 58-59
Abu Simbel, 21
Achaemenid kings, 32-33, 40
Afghanistan, 9, 33, 56
Agamemnon, 25
Akhenaten, 20-21
Akhetaten, 20
Akkad, 12-13
Akrotiri, 23
Alexander the Great, 21, 31, 44-45
Alps, 47
Ammenemes III, 17
Amorites, 13
Ampharete, 43
Apadana, 33
Ashurbanipal II, 27, 29
Ashurnasirpal II, 26, 27, 28, 29, 46
Asia Minor (Turkey), 9, 20, 22, 24, 32, 33, 34, 36, 38, 40, 44, 45, 49 , 51
Assyria, 21, 26-29, 30, 46
Aswan Dam, 21
Athens, 24, 36, 38, 39, 40-41, 42-43, 44
Augustus, 50, 52

Babylon, 13, 29, 30-31, 32, 33, 45
Baghdad, 58-59
black-figure vases, 38-39
Black Sea, 36
Botta, Paul Emile, 29
bricks, 8, 30-31, 33
bucchero pottery, 49
Byblos, 46

Caesar, Julius, 50
Cairo, 59
Carthage, 47
centaurs, 40, 41, 53
Cerveteri, 48-49
Chaeronea, 44
Chaldeans 29, 30
Cheops, 15
Chephren, 15
coins, 44, 47
Colosseum, 52
Commodus, 55
Constantine, Arch of, 51
Constantinople, 51
Cordoba, 57, 59
Corinth, Isthmus of, 43
Crete, 22-23, 24
Cyclopean walls, 24
Cyclopes, 24
cylinder seals, 9
Cyprus, 22, 25, 36, 46, 47
Cyrus the Great, 31, 32

Dacia, 51
Damascus, 56, 58
Darius I, 33
Delphi, 36, 37
Dexileos, 43

Egypt, 14-21, 22, 26, 32, 34, 45, 46, 48, 59
El-Amarna, see Akhetaten
Elgin, Lord, 41
Elgin Marbles, 41
Eridu, 9
Etruria, 48-49, 50, 54
Evans, Sir Arthur, 22

France, 36, 47
 freed slaves, 54

Giza, 15
gods and goddesses, 10, 13, 15-16, 20, 23, 26-28, 30-31, 35-39, 41, 47, 52-53
Adad (Babylonian), 31
An (Sumerian), 10
Apollo (Greek), 37, 41
Artemis (Greek), 41
Ashu (Assyrian), 26-28
Aten (Egyptian), 20
Athena (Greek), 36, 41
Atlas (Greek), 37
Baal Hammon (Carthaginian), 47
Bacchus (Roman), 53
Dionysus (Greek), 38-39
Dumuzi (Sumerian), 10
Enki (Sumerian), 10
Enlil (Sumerian), 10
Hera (Greek), 37
Horus (Egyptian), 15
Inanna (Sumerian), 10
Ishkur (Sumerian), 10
Ishtar (Babylonian), 30-31
Marduk (Babylonian), 30-31
Minoan, 23
Nanna (Sumerian), 10
Neptune (Roman), 52
Osiris (Egyptian), 16
Poseidon (Greek), 41
Re (Egyptian), 15
Shamash (Babylonian), 13
Tanit (Carthaginian), 47
Utu (Sumerian), 10
Zeus (Greek) 35, 37
Granada, 59
Greece, 22, 23, 24-25, 34-45, 48, 49, 50,52,53, 55
Guti, 13

Hadrian, 53

Hamadan, 33
Hammmurabi, 13, 30
Hannibal, 47
Hatshepsut, 18-19
Hattushash, 21
Hector, 39
Helen, 39
Heracles, 36, 44, 55
Hercules, see Heracles
Hesire, 14
Hesperides, 36, 55
Hippias, 36
Hittites, 20-21
Homer, 25
Hyksos, 18

Iliad, 25
Iran, 13, 26, 29
 see also Persia
Ishtar Gate, 30-31
Israel, 28
 see also Palestine
Istanbul, 51
Italy, 24, 36, 47, 48-49
 see also Etruria, Rome
ivory, 46, 59

Jerusalem, 30, 57
jewelry, see metalwork
Judah, 28
 see also Palestine

kerameikos, 38
Khirbat al-Mafjar, 58
Khorsabad, 26, 27, 29
Knossos, 22-23
Koran, 56-57
kouroi, 34-35
Kufa, 56
Kurdistan, 26

Lachish, 28
Lagash, 9, 11
Layard, Henry, 29
Lebanon, see Phoenicia
Lion Gate, 24
Luristan bronzes, 32

Macedon, 44
Mallia, 22
Marcus Aurelius, 50
Mari, 13
Mecca, 56
Medes, 29
Medina, 56
Memphis, 14, 17
Menna, 19
Mentuhotep I, 16-17
Mesopotamia, 8-13, 26, 34, 58

metalwork
 Etruscan, 48-49
 Hellenistic, 45
 Islamic, 59
 Mesopotamian, 9
 Minoan, 22-23
 Mycenean, 24-25
 Persian, 32-33
 Phoenician, 46-47
Minos, 22
Minoans, see Crete
Minotaur 22
mosaic, 52-53, 57
Muhammad, 56-57, 58
museums
 British Museum, 29, 41
 Louvre, 29
 Staatliche Museum, 30, 44
Muslims, 56-57, 59
Mycenae, 23, 24-25
Mycerinus, 15

Nabonidus, 31
Nabopolassar, 30-31
Naramsin, 12
Nebuchadnezzar II, 30-31
Nimrud, 27, 28, 29, 46
Nineveh, 27, 28, 29
Nippur, 8, 9
Nubia, 16, 18, 21

Octavian, see Augustus
Olympic Games, 37
Olympia, 37
Ostia, 52

painting
 Egyptian, 19
 Etruscan, 48, 49
 Minoan, 22
 Mycenean, 24
 Roman, 52, 53
Palestine, 18, 20, 21, 24, 26, 30
 see also Israel, Judah
Paris, 39
Parthenon sculptures, 40-41, 43, 44
Pasargadae, 33
Peloponnese, 43
Peloponnesian War, 43
Pepi II, 16
Pergamum, 44, 45,
Pericles, 41
Persepolis, 33
Persia, 9, 12, 21, 31, 32-33, 40, 57, 59
 see also Iran
Phaestos, 22

Philip II, 44
Phoenicia, 28, 30, 34, 46-47, 48
Pompeii, 53
Pottery
 Etruscan, 48, 49
 Greek, 38-39, 42-43
 Islamic, 59
 Minoan, 22, 24
 Mycenean, 24, 25
Processional Way, 30-31
Ptahhotep, 15
Punic Wars, 47
 see also Phoenicia, Phoenicians
Puzur-Ishtar, 13
Pylos, 24
pyramids, 14, 15, 17, 21

Qadesh, 21
Qasr al-Hayr al-Gharbi, 58

Ramesses II, 21
red-figure vases, 38-39
rivers

Arno, 48
Euphrates 8, 28, 30
Indus 9,
Nile 14, 16,
Tiber, 48
Tigris, 8, 26
Rome, 47, 49, 50-55
Romania, see Dacia

Samarra, 59
Santorini, see Thera
Sardinia, 47
Sargon II, 26, 29
sculpture
 Assyrian, 26-29
 Carthaginian, 47
 Egyptian, 14, 15, 16, 17, 18, 20, 21
 Etruscan, 48
 Greek, 34-37, 40-41, 42-43
 Hellenistic, 44-45
 Islamic, 58
 Mesopotamian, 11, 12, 13
 Mycenean, 24
 Persian, 32, 33

Roman, 50-51, 54-55
Sennacherib, 28, 29
Sesostris III, 17
Seville, 59
shell, 10
Sicily, 24, 36, 47, 48
Sidon, 46
Siphnos, 36
Spain, 38, 46-47, 49, 57, 59
Sparta, Spartans, 40, 43, 44
Suppululiumas, 21
Susa, 33
Syria 9, 12, 13, 18, 20, 21, 24, 26, 28, 30, 45, 48
Sumer, 8-11, 12, 13

Tarquinia, 49
Thebes (Egypt), 16, 17, 18, 19, 20, 21
Thebes (Greece), 24
Thera, 23
Theseus, 22
Thrace, 44
Tiryns, 24
Tivoli, 53

Tower of Babel, 30
Trajan's Column, 51
Trojan War, 25, 39
Tutankhamun, 20-21
Tuthmosis III, 18-19
Tyrannicides, 36
Tyre, 46

Umayyads, 58
Ur, 9, 10
UrNanshe, 11
Uruk, 9, 11

Valley of the Kings, 21
Vespasian, 55
volcanoes, 23, 53
Vulci, 49

white-ground vases, 42
wood, 10, 16, 57
writing, 8, 9, 22, 24, 34, 56, 57

Zagros mountains, 13, 32
Zakro, 22
ziggurats, 8-9, 30